A–Z

OF

SOUTHEND

PLACES - PEOPLE - HISTORY

David C. Rayment

AMBERLEY

I dedicate this book to
Joyce Alma Rayment
1923–2013

First published 2019

Amberley Publishing
The Hill, Stroud, Gloucestershire, GL5 4EP
www.amberley-books.com

Copyright © David C. Rayment, 2019

The right of David C. Rayment to be identified
as the Author of this work has been asserted in
accordance with the Copyrights, Designs and
Patents Act 1988.

ISBN 978 1 4456 8647 9 (print)
ISBN 978 1 4456 8648 6 (ebook)

British Library Cataloguing in Publication Data.
A catalogue record for this book is available
from the British Library.

Typesetting by Aura Technology and Software
Services, India. Printed in Great Britain.

Contents

Preface

When asked to write a book about any subject the author is invariably faced with space constraints. What to include and what to leave out is often a subjective decision. Writing an illustrated A–Z, where something has to be included for each letter of the alphabet, including X Y and Z, is no exception. This book, therefore, does not claim to be a comprehensive history of the Borough of Southend, which would take many volumes. Its purpose is to simply offer the reader, in an alphabetical format, a sense of place, a flavour of what Southend is: to take a look at a few of the people who helped establish it; to look at some of the individuals who have contributed to the borough's history, if only by their temporary presence; and to look at contemporary views of places of interest. Doing the research for this book and the taking of the photographs has certainly been an interesting journey. It is hoped that in reading the text and the visual narrative, the reader finds the journey of interest, too. Welcome to Southend.

The Cliff Lift at the end of the High Street for access to the pier and seafront.

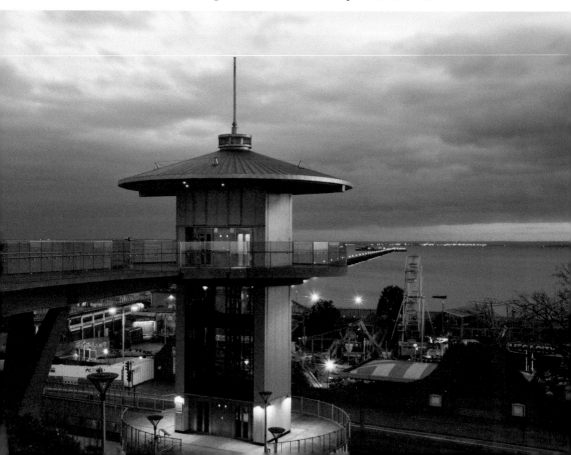

Introduction

Southend is primarily a Georgian creation from a small fishing hamlet with a series of oyster beds situated at what was then the south end of the old Prittlewell parish within the Rochford Hundred. The town is built on London Clay, on sedimentary bedrock laid down during the Eocene epoch of the Caenozoic era around 50 million years ago. It stands partly on a layer of gravel on the north bank of the River Thames near the mouth of that river, which flows west towards England's capital city and beyond. Its mudflats are a haven for wildlife and the seagoing vessels that have passed its shores include the *Northumberland*, which at one time, when under the command of Sir George Cockburn (1772–1853), transported Napoleon I (1769–1821) to St Helena after the emperor's surrender. The *Endurance*, too, passed Southend's shores in August 1914, when the explorer Sir Ernest Henry Shackleton (1874–1922) left that ship at Southend Pier to return to London to meet the king before his Antarctic adventure. Perhaps the most noticeable vessel to pass Southend's shores, however, was HMS *Victory*, when on that solemn occasion at the end of December 1805, and having received a few repairs at Portsmouth, it carried the remains of Admiral Lord Nelson (1758–1805) from that place to the Nore. The following day Nelson's body was transferred from the *Victory* to one of the king's yachts for transporting to Greenwich Hospital where it was to be prepared for laying in state.

On a more cheerful note, Prittlewell's south end was a much-admired bathing resort during the summer season at least as early as the 1780s, with a 1786 newspaper advertisement for a property in nearby Rochford singing its praises and indicating its close proximity to that property a benefit. At the time there were very few buildings along what is now Marine Parade. Thomas Archer, a curate at Prittlewell Church, wrote a *Poetical Description of New Southend* in 1793 and he describes the journey from the then newly built Grand Hotel to a place near what was the Ship Hotel:

> Eastward a steep and narrow road descends,
> Which to the level plain its course extends,
> Here, without order, several houses stand,
> Scattered along the shore, and near the Strand;
> Some built in lofty style, of modern date,
> Some long erected, and of lowly state

By the early 1800s Southend had become a bathing resort for the well-to-do, being visited by the Princess of Wales and several members of the gentry and clergy, with a few taking up summer residence. No doubt its salubrious air, favourable climate and close proximity to London assisted its popularity.

Certainly, by 1815 the benefits of Southend's air quality and the saline qualities of its coastal waters had reached the little village of Chawton in Hampshire where the author Jane Austen (1775–1817) was writing her novel *Emma*. Of Southend she writes, 'Mr Wingfield most strenuously recommended it, sir – or we should not have gone. He recommended it for all the children, but particularly for the weakness in little Bella's throat – both sea air and bathing.'

It was not until 1842, however, that Southend became a parish in its own right with the building of an episcopal chapel near the top of Pier Hill. This was a much-welcomed new building for Southend inhabitants and visitors alike, as they were now able to worship locally rather than having to travel in excess of the mile and a half to St Mary Virgin, Prittlewell. Even so, Southend was still considered by some to be a 'small Watering-Place', which is how Queen Victoria referred to it in her journal as she passed by on the *Royal George* when sailing down the River Thames.

Popularity for Southend increased further with the coming of the first railway in 1856 and the building of the original Southend Central station. No longer were visitors to the town dependant on the coach, the horse and chaise, or the regular ships that plied their trade from London to Southend. The journey from London to Southend by road was an arduous one with several stops on the way. In 1806 Richard Wicks, who was based at the Post House, White Hart Inn, Brentwood, advertised in the *Morning Post* that he had increased the number of horses and chaise available at each stop-

St Mary the Virgin, Prittlewell, the old parish church for Southend.

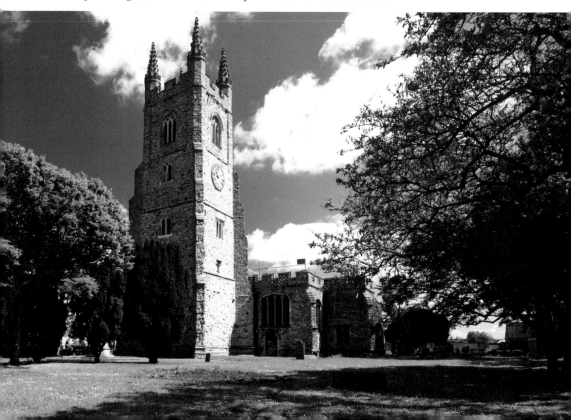

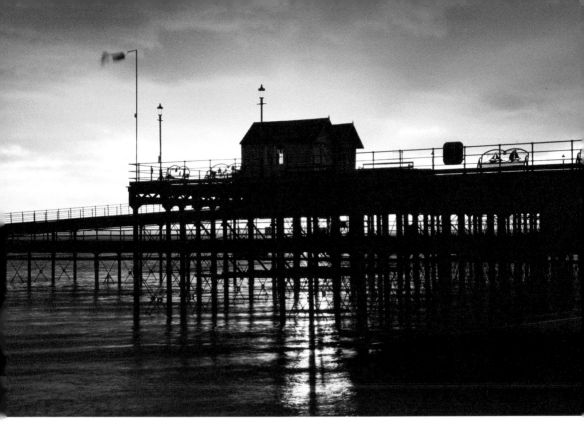

'The pier is Southend, Southend is the pier' – Sir John Betjeman.

off point from London to the new seaside resort. The first leg of the journey was from London to Ilford, then Ilford to Brentwood (11 miles), Brentwood to Wickford (12 miles) and finally Wickford to Southend (14 miles). There was also a problem in travelling by ships in those early days in that the existing jetty was too short for the embarkation of passengers at low tide. The passengers had to board a rowing boat, which would take them to a horse-drawn carriage so that they could safely continue their journey to shore. Alternatively, they could use the less dignified method of transport by piggy-back across one of the two causeways from the rowing boats to dry land. That problem was eased when the newly built wooden pier, which replaced the jetty, was extended in 1833. The present iron structure was completed in 1890.

On 3 October 1859, shortly after the coming of the railway, the then Lord of the Manor, Daniel Robert Scratton, laid a foundation stone for what was to be the building of a new town. He had owned much of the land on which modern Southend is built, before selling up and buying an estate near Newton Abbott in Devon.

With the arrival of Southend's first railway station and the foundations of a new town having been laid, it was time for the opening of a new station, Southend Victoria, which further assisted travel from London. Thus there were now two main railway routes into Southend. For several years though, the rail line extension from Wickford to Southend Victoria was only single track between Wickford and Prittlewell where it was again doubled to Southend Victoria station. It is clear, however, the coming of the railways, which were encouraged by Southend's growth, in turn encouraged further

development at Southend and its surrounding area, which eventually became part of the daily commuter belt offering easy access to London.

On 15 August 1892 a charter was granted by Queen Victoria for Southend to hold Borough status and Prittlewell, once Southend's mother parish, became part of the Borough of Southend. The borough continued to grow in size, later incorporating the old village and harbour of Leigh to the west, where historically the primary occupation was the dredging for oysters and later the collection of shrimps, an industry which at Leigh was founded by Stephen Frost in the 1830s. Leigh is also well known for its cockles and for centuries as a home to mariners. As well as the old village there is a later built town at the top of the cliff, east of St Clement's Church.

To the east of Southend the parishes of North and South Shoebury were added, South Shoebury being a Garrison town from the mid-nineteenth century, but now mainly residential, although the Ministry of Defence still has a presence in the area.

It was Southend itself, however, rather than its environs, which attracted most of the day trippers from London, reaching its heyday in the 1950s and 1960s. The clichéd 'kiss me quick' hats could be seen on the heads of individuals sitting on the beach or on one of the 24,000 deckchairs available, perhaps holding an ice cream or a stick of Southend Rock, purchased from one of the many kiosks along the seafront.

Away from the beach the main area visited was Marine Parade, known as the 'Golden Mile', with several places selling refreshments alongside the amusement arcades.

Leigh High Street. The original Crooked Billet was built in Tudor times.

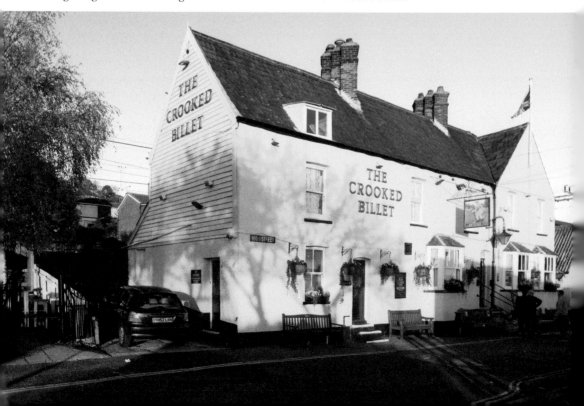

Above: The High Street outside the old garrison gates with the Shoeburyness Hotel on the left.

Below: Five of the six lighting masts on Marine Parade with the Kursaal in the background.

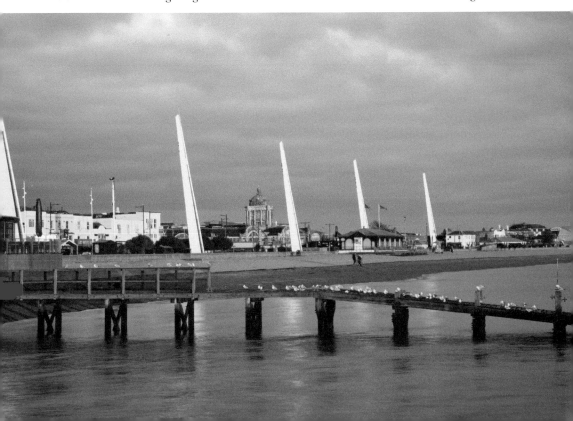

Like most seaside resorts, however, the number of visitors to Southend began to decline when the European package holidays became more affordable; but despite the popularity of the Continental holiday, Southend is still a very popular seaside resort today, and it has recently seen a rise in visitor numbers.

Money has been spent modernizing Southend with the installation of a twin lift tower at the end of the High Street, giving easy access to the pier and the seafront. The free to use lift is operational at times to suit most people, but do check times at the gate before going down if you need to rely on it. Also installed along the seafront is six lighting masts, each just over 21.5 metres high. Nearby, there is the water fountain area where the children enjoy playing during the warm summer months. The jets of water change height throughout the day and at night are lit by a variety of colours.

Southend has its own airport, with its recently purpose-built railway station and it is now a university town, occupied by the University of Essex. It is one of their building complexes, University Square, which catches the eye of most passers-by. The building is actually student accommodation and is known locally as the 'Lego building' because it reminds people of the building bricks of that name.

The south end of Prittlewell parish has certainly grown enormously since its early days as a humble fishing hamlet, and at the time of writing the Southend West MP, Sir David Amess, is very supportive of a campaign to promote Southend to City status. Apart from the possible exception of its churches, St Mary Prittlewell and St Clement Leigh, Southend lacks a defining skyline. Any city, however, needs its history as a foundation on which to build and Southend certainly has plenty of that, but it is sadly often overlooked by the visitor, unaware of its existence.

Below left: The water jets display with changing colour lights.

Below right: University Square is known locally as the Lego building.

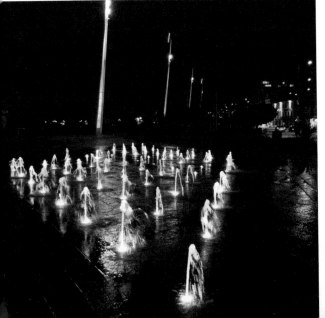
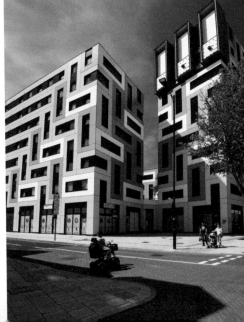

A

All Saints Church

All Saints Church began as a temporary iron building erected in June 1877 and was opened by the Bishop of St Albans on 28 July of the same year. It became the parish church of Porters Town, a new parish formed to accommodate Southend's increasing population during the nineteenth century. The church was built on land given by Elizabeth Alice Heygate, who also donated a substantial sum of money towards the cost of a church building.

Elizabeth, who was the second daughter of James Heygate junior and Anna (Macmurdo), lived for many years at Porters Grange, which is on the south side

All Saints Church, Southchurch Road.

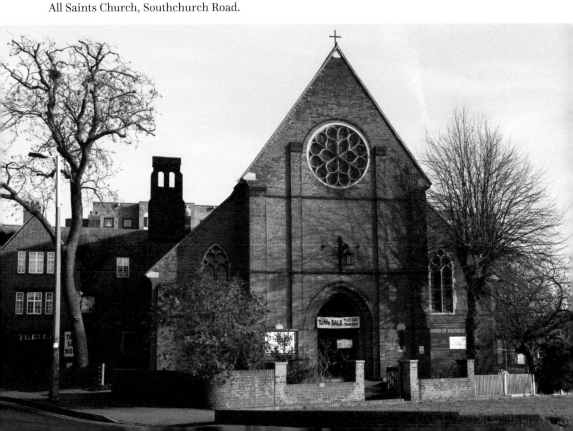

opposite where the church of All Saints stands. She died on 29 December 1876 and was buried at All Saints Church, Banstead, Surrey, on 4 January the following year, thus only a few months before the erection of the temporary iron church at Porters Town. There is, however, a plaque to her memory within the Borough of Southend and this is on the wall inside the church of St Mary the Virgin, Prittlewell.

The red-brick church we see today was designed by James Brooks (1825–1901), a Fellow of the Royal Society of British Architects and a designer of several churches in the London area. The foundation stone was laid down on 31 July 1886 by Lord Brooke, with a full masonic ceremony, he being the Grand Master of the Essex Provincial Grand Lodge of Freemasons. The church was completed two years later. It was not until Wednesday 19 June 1889, however, that the act of consecration was performed by Alfred Bromfield, the Bishop of Colchester. Monies were received at the consecration ceremony and in July 1885 a garden fete and fair was held at the Lodge, courtesy of John Spencer Weston and under the patronage of Princess Louise.

Elizabeth Heygate's brother, the Revd Thomas Edmund Heygate of Sheen in Staffordshire, also took an interest in All Saints Church. He moved to Southend on retirement shortly after the death of his wife in 1890, thus he was able to attend services at the new church his sister helped fund but never saw. Thomas lived at Porters Grange, too, until his death on Saturday 5 May 1910, at the age of seventy-four.

The church building was added to in the 1920s and 1930s with designs by another architect, Sir Charles Archibald Nicholson (1867–1949). He married his second wife, Catherine Warren, at All Saints in June 1931.

B

Bacon, Lady Charlotte

Lady Charlotte Mary Bacon was a tenant at Porters Grange, Southend, during the period of ownership by Sir Frederick William Heygate, the son of Sir William Heygate.

Born as Charlotte Mary Harley in 1801, she was legally the daughter of Edward Harley, 5th Earl of Oxford and Mortimer. She came to fame at the tender age of twelve, when Lord George Gordon Byron (1788–1824) visited her parents' house and was so struck by the young Charlotte's charm and beauty he immortalized her in the lines of *To Ianthe*, the prologue to a poem dedicated to Childe Harold. Byron also commissioned the portraitist Richard Westall RA (1765–1836) to paint her portrait. This was used to illustrate the poem.

Lady Charlotte married Anthony Bacon (1796–1864), a colonel who was later promoted to major general. He had fought in the Napoleonic Wars and was a recipient of the Waterloo Medal. The marriage took place in Paris on 15 February 1823. Shortly after his death Lady Charlotte boarded the *Aldinga III* bound for Australia where her three children had emigrated. For nearly ten years she lived at Smith Street in the Walkerville District of Adelaide. Charlotte returned to England after nearly a decade, but in 1874 it was back to Australia, accompanied by her son Alfred Harley Bacon. It was after this visit to the southern continent she again returned to England and became a tenant at Porters Grange.

In 1879 members of the Essex Archaeological Society thanked Lady Charlotte for allowing them to see inside the building. Major Thomas Jenner Spitty of Billericay, who owned Lake Meadows just north of that town, was in the group of visitors. Lady Charlotte died at No. 13 Stanhope Place, her London residence, on 9 March 1880, so her tenancy at Porters Grange was of short duration.

Bow Window House

Built in the 1790s, Bow Window House is easy to find for it sits at the foot of Pier Hill. Its ground-floor frontage, which was designed in the twentieth century, however, is far removed from how it looked in the early nineteenth century when its occupant was Lady Charlotte Denys. Gone are the small front garden and the later built veranda.

Bow Window House and Marine Terrace.

Lady Charlotte was the daughter of George Fermor, the 2nd Earl of Pomfret, and his wife Anna Maria De La Gard (later Draycott). They both attended a ball and supper at Southend's Grand Hotel (later Royal Hotel) in the summer of 1799. Charlotte was born in 1766 and on 21 July 1787 when officially still a minor, her father gave his consent for her to marry Peter Denys at Easton-Neston, Northamptonshire. After marriage their main place of residence was the 'Pavillion' in Hans Place, situated on the west side of Sloan Street in the parish of St Luke, Chelsea. It was when Bow Window House came on the market in 1810, however, that Peter Denys bought it. When he died on 15 July 1816 the property was left to Lady Charlotte. Lady Charlotte continued to use the property until 1829, at which time the house was taken over by the occupancy of James Bullock of Holborn, London, who opened up the building as the Marine Library. The word 'Marine' was written below the third-floor window on the west side and 'Library' below the third-floor window on the east side. His activities whilst at the Marine Library are listed as running a circular library, a printer, bookseller and stationer. He is also noted as being a dealer in cutlery, soap and fancy articles. He brought competition to the area. Mrs Harriet Renneson at the nearby Royal Library was somewhat concerned by this. Bullock, however, was no stranger to bankruptcy and he soon moved out, so Harriet need not have worried. The executors of Peter Denys put Bow Window House up for auction in 1836, after Lady Charlotte's death on 18 November 1835. At the time an Ann Lingood was the tenant of the house. The property was bought by a Chelmsford resident, John Copland. He died in 1845. The next purchaser appears to have been Mr Nixon and at the time of his ownership Bow Window House was known as Marine House. Sometime between 1852 and 1860 a terraced house extension was added to the west side of the building. The extension, which was known as Marine Terrace, is easily identified by its façade being set further back from the road and by its higher roof. Also, the outline of building blocks can be seen on the front of the old building, but not on the later middle section.

Bow Window House was again put up for auction in 1876 after the death of Mrs Nixon. Before then, in 1873, Marine Parade was renumbered after complaints about the irregular numbering system in existence. However, when Bengal-born Eliza Porter died in 1876, her address was still given as Marine Terrace. Thus, the

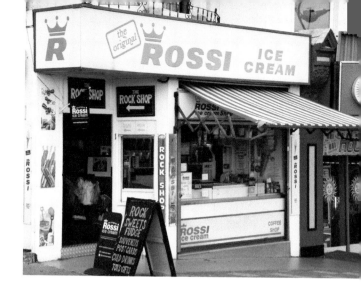

The Rossi Ice Cream shop at No. 1 Marine Parade (1 Marine Terrace).

westernmost dwellings were, for a short period of time at least, No. 1, 2 and 3 Marine Terrace and No. 1, 2 and 3 Marine Parade. George Myall, Southend's first coxswain, lived at No. 1. The next occupant of No. 1 was the Italian-born Peter Zanchi who at one time also occupied No. 6 and 7 Marine Parade. Peter sold ice cream from here and advertised supplying the same to the mayors of Southend. Peter also sold ice cream and other confectioneries from the kiosk a few yards west of the pier entrance. In 1932 another Italian paid £3,500 for No. 1. The purchaser was Mr Massimiliano Rossi. Rossi Ice Cream based on the original recipe is still sold at No. 1 Marine Parade today.

There were several occupants of Bow Window House after Mrs Nixon, one of whom was James Colbert Ingram, three times a Southend mayor. By 1898, however, the property became Granville Hotel and Restaurant. At this time the name 'Granville' appeared below each of the two third-floor windows, replacing 'Marine' and 'Library'.

Buchanan, Robert Williams

Robert Williams Buchanan was a successful practitioner of the arts, an accomplished dramatist, essayist, novelist and poet. He was born on 18 August 1841 at Caverswall, a small village near Cheadle in Staffordshire. Robert was the son of Robert Buchanan, a Scotsman, missionary and journalist, who later owned and edited the *Glasgow Sentinel*. His mother, Margaret (Williams), was a native of Somersetshire.

Young Robert spent his early years in Hampstead, but he was educated at Glasgow, leaving Scotland for London in 1860 where he worked as a journalist in Fleet Street. In 1862 Robert published his first work, *Undertones*. His first book, *Idylls and Legends of Inverburn*, was published the following year and this was followed in 1866 with *London Poems*. His first novel, however, *The Shadow of a Sword*, was not published until 1876. As a playwright his greatest success was probably *Witchfinder*, which was performed at the Sadler's Wells Theatre in 1874.

In 1885 Robert co-wrote a play with his sister-in-law entitled *Alone in London*. Harriet Jay, born at Grays in Essex, was the author of several works, including

The Queen of Connaught published when she was in her late teens. She also had a desire to act and used pseudonyms when she was learning the technicalities of her acting trade. Harriet used a pseudonym for writing, too, and wrote the farce *When Knights Were Bold* under the name Charles Marlowe. This achieved much success and was later made into a film on four occasions, including an Italian version. Harriet's stage debut using her real name, however, was at the Crystal Palace in November 1880.

The month following Harriet's Crystal Palace appearance, she played Lady Jane Grey in Robert Buchanan's *The Nine Days Queen*, a play based on *The Tragedy of Lady Jane Grey* (1715) by Nicholas Rowe (1674–1718).

Robert loved Southend and spent much time there during his later years. On his death at Harriet's home in Streatham his body was transported to Southend where he was buried in the churchyard of St John the Baptist, alongside his wife, Mary. On 24 July 1923 Harriet, accompanied by Thomas Power O'Connor (1848–1929), a journalist, MP and 'Father' of the House of Commons, officiated the ceremony for the unveiling of Robert Buchanan's bust memorial, which is situated at the north end of the churchyard. There is a memorial inscription there for Robert's mother, as there is for Robert's friend and sister-in-law who were both buried in the churchyard. Harriet died at Ilford, Essex, on 21 December 1932.

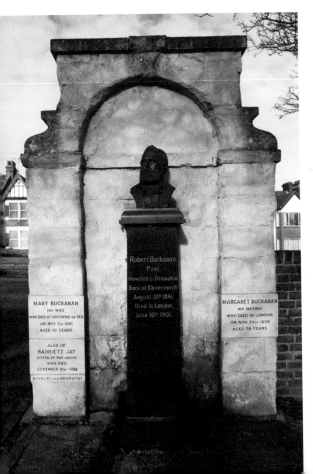

The Robert Williams Buchanan memorial at St John the Baptist churchyard.

C

Clifftown Congregational Church

By courtesy of a visiting minister, nonconformists began preaching at Southend in the late 1790s and this took place at No. 3 Grove Terrace. At the turn of the century a room above the Royal Library (which faced the Royal Hotel) was used. In 1806, in order to accommodate the growing congregation, a purpose-built chapel was constructed on land donated by the banker James Heygate and this became the congregations' new home. For several decades, however, the nonconformists of Southend found their No. 10 High Street chapel no longer met their needs, falling short in the number of people it could accommodate, even though it had been enlarged in 1814, on more land donated by Heygate. In 1864 a committee was formed to oversee the building of a new church in Nelson Street. This was to be built on land supplied by the Clifftown Building Association. It was originally proposed that the church be sited at the north end of Nelson Street where the Railway Hotel is today, but the present site was later chosen.

Clifftown Congregational Church in Nelson Street.

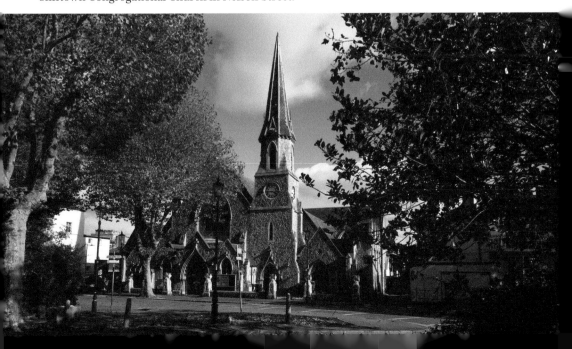

Work began on the new church on 18 April 1865, and on 30 May 1865 the foundation stone (under which was placed a manuscript giving the history of the church in Southend) was laid down by Isaac Perry of Chelmsford. Later the same year the church came into service. The building, designed by William Allen Dixon (1821–93), was built in the Gothic style and is primarily made of Kentish ragstone. It cost around £2,500 to build. Bazaars were held to raise money – even for several years after the church was built – and contributions for items to sell on the stalls came from far and wide, with one lady making a contribution from the Isle of Man.

The church is now a Grade II listed building, but is no longer a place of nonconformist worship. It is, however, occupied by East 15 acting school, housing Clifftown Studios and Theatre (University of Essex).

Cosmos 253 – a Personal Account

Southend has a link with the Soviet space programme, albeit a rather tenuous one. On 20 November 1968 I was walking towards Wickford railway station having just left a friend's house, when a very bright white light suddenly appeared in the southern night sky, traversing the sky from west to east. The light then appeared to split into several lights of near equal brightness, which reminded me of the Roman candle fireworks that had been on sale a couple of weeks earlier. The bright white lights then faded, turning into a dim red before disappearing. What I saw was logged by the Royal Aerospace Establishment at Farnborough as the breaking up of a cylinder measuring 7.5 metres long with a diameter of 2.6 metres. It had the technical designation 1968-106b. The cylinder was part of the rocket that launched the Soviet photoreconnaissance satellite Cosmos 253, re-entering the Earth's atmosphere. The rocket, launched on November 13, reached a maximum height of 309 kilometres above the Earth's surface. On re-entering the top layer of the atmosphere, the rocket began to fragment at very high temperatures, but began to cool as it reached lower levels, thus the change in colour from white to red. Fragments of the rocket were picked up at Southend. Fortunately, no one was hit by the debris.

D

Dr George Davidson Deeping and Son

George Davidson Deeping was a resident of Southend for twenty-eight years, where he was a much-respected medical practitioner and participator in local affairs. Dr Deeping was the son of William Davidson Deeping and Elizabeth. He was born in 1848 at the Lincolnshire village of Swinderby, close to the Nottinghamshire border, 6 miles north-east of Newark-on-Trent where the family later lived. George was educated at Newark Grammar School and later entered the medical profession. At Guys Hospital he received the Treasurers Gold Medal for Medicine for the period 1870 to 1871 before becoming a dresser and a surgeon at that hospital. In 1872/3 he came to Southend and joined Dr Warwick, taking over Warwick's position when that doctor retired in 1875. In 1873 he married Marion Warwick, Dr Warwick's second daughter. They lived at No. 8 Royal Terrace, once occupied by the Princess of Wales, and later No. 19 Royal Terrace before the doctor retired to St Helen's Hastings in 1900, which is where he died in 1909. A memorial service was held at St John the Baptist in Southend, a church where Deeping regularly held a Bible class for young men.

Marion and George had a daughter, Marion, and a son, George Warwick Deeping, better known as Warwick Deeping. Warwick was born at the Royal Terrace in 1877. He, like his father, trained in medicine with a view to having a career in that profession. Warwick, however, after a year as a qualified doctor practising in Berkshire, decided to become a full-time writer. His writing career was interrupted during the First

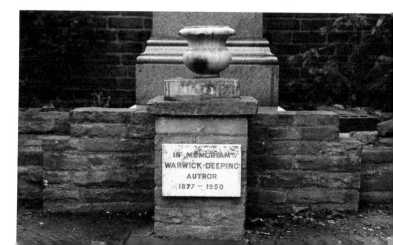

The Warwick Deeping memorial at St John the Baptist churchyard.

World War when he became a temporary major in the Royal Army Medical Corps, serving in Gallipoli and Egypt.

Warwick perhaps achieved most success as an author in the 1920s and 1930s. His best-known novel was *Sorrell and Son*. He died in 1950 at his home in Weybridge, Surrey, and was cremated at Woking Crematorium. However, there is a memorial to him at Southend near the north wall of St John's churchyard.

Dowsett, Thomas (JP)

Thomas Dowsett is best known for being Southend's first mayor. He was born in Prittlewell of humble beginnings. His first job is said to have been as a human scarecrow on land adjacent to Victoria Avenue, which he later bought, and where he later lived until his death at Rayne Villa. His next job was as a journeyman hairdresser and barber, although he also traded from 13 Marine Parade, which was around where the amusement arcade Electric Avenue is today. At the age of eighteen he financed his own hardware store and later traded from the High Street in the building on the corner of Alexandra Street, now in the occupation of Royal Fish & Chips and the next door Stylers. Outside this building he funded Southend's first granite kerb and asphalt pavement.

In 1899 he and Clarrisa, his second wife, travelled on board the RMS *Etruria* with the Cunnard Steamship Company, to New York and back. The ship won the Blue Riband in 1885 and 1888, both on its westward-bound journey.

Thomas, his first wife and his second wife are buried at St John the Baptist churchyard where there is an obelisk memorial to all three persons on the north-west side.

Below left: Thomas Dowsett traded from this building in the High Street.

Below right: The Thomas Dowsett obelisk memorial in St John the Baptist churchyard.

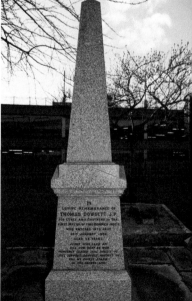

E

Explosion at Shoebury

On 26 February 1885 there was an explosion at the Brick Battery near the Garrison Pier in Shoeburyness. The accident occurred when sensitive fuses, the invention of Colonel Lyon of Woolwich, were being experimented with at the School of Gunnery. The experiment appears to have been a success until an attempt was made to place a fuse in the last 6-inch shell. Gunner Robert Allen tried with some force to screw the fuse in place when the shell exploded. He was killed in the accident, as were six other men, each receiving horrific wounds. Telegrams were sent to London and surgeons were rushed to the scene to help survivors. The London, Tilbury and Southend Railway Company put on a special train and cleared the whole line to enable fast

The Heavy Quick Fire Battery, built in 1899, as seen from the rear.

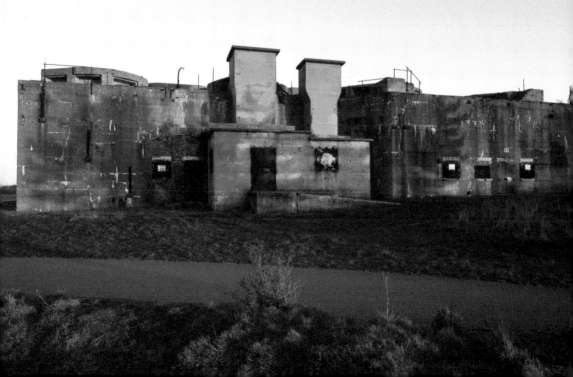

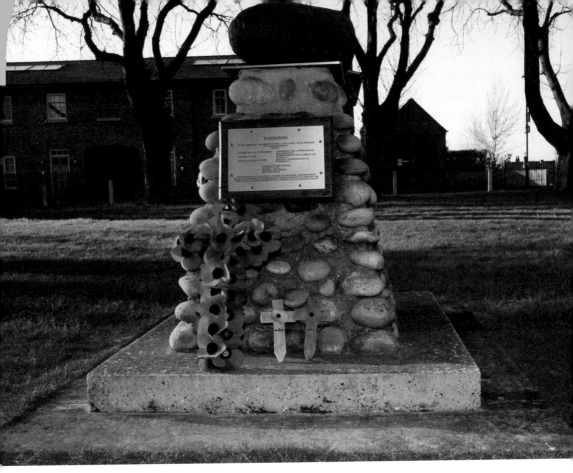

The memorial to those seven men killed in the accidental explosion.

travel. Meanwhile, William Coupe (the father of Shirley Coupe mentioned in my book *Southend History Tour*) helped the wounded, using his expertise as a chemist. William was later presented with a clock by the 224 officers, non-commissioned officers and men of the garrison for his assistance at this tragic event. Those killed were: Colonel Walter Aston Fox-Strangeway, Colonel F. Lyons, Captain Francis Michael Goold-Adams, Gunner Robert Allen, Sergeant-Major Samuel (Sam) Daykin, Gunner James Underwood, and Artificer James Frederick Rance.

There is a memorial at Shoebury to all seven men. It was unveiled by Colonel R. A. Spackman in 1995, 110 years to the day after the accident.

F

Funicular Railway

This 130-foot-long funicular railway is one of only a few built in the UK and is thought to be the shortest. It was built to a 4-foot 6-inch gauge and enables its passengers to travel the cliff face from the Western Esplanade to Clifftown Terrace, and vice versa. The lift was opened in August 1912 – although the carriage and boarding area has changed several times since then. The original was built by R. Waygood & Co. Ltd, which began trading in the first half of the nineteenth century. In 1894 the business became a private limited company, but the company went public in 1900 in order to

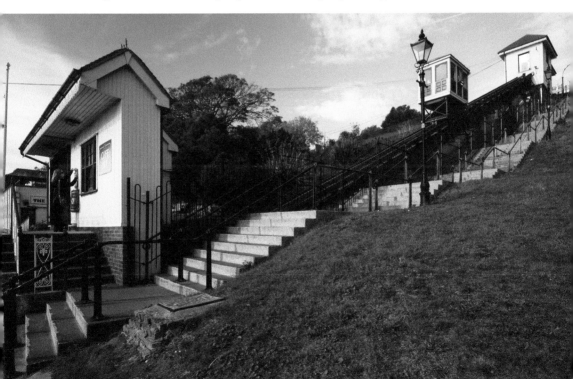

The funicular railway showing upper and lower entry points.

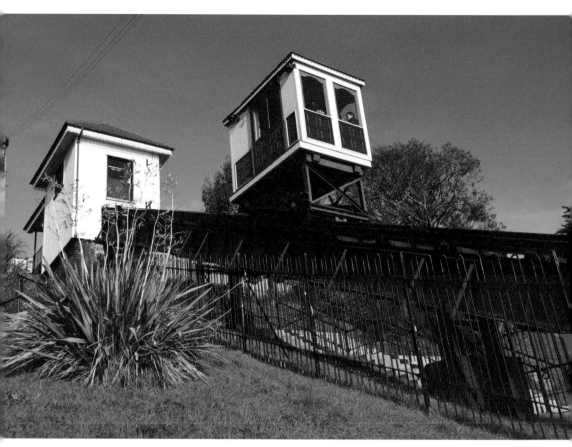

The lift railcar on its upward journey.

raise funds to assist its expansion. Before the Southend build the company installed cliff lifts in 1910 at Ramsgate and Margate. As a private company the business built lifts for the Duke of Wellington and for Queen Victoria at Balmoral, Windsor Castle and Buckingham Palace. R. Waygood & Co. also built lifts for several ships, including the ill-fated *Titanic*. The Southend cliff lift is operational during the summer months, but only when volunteers are available to operate it.

G

Garrison at Shoebury

Shortly after Christmas 1846, Lieutenant Colonel J. A. Chalmers, who was the Assistant General of Artillery, and Major Sandham of the Royal Engineers, left Woolwich Barracks to visit the parish of South Shoebury. They were later accompanied by Sir Thomas Hastings of the Royal Navy and others. The purpose of the visit was to survey grassland with the intention of erecting new batteries and barracks to complement the newly placed artillery practice range. Further surveys were undertaken and it was proposed there would be two departments at Shoebury, each with one field officer. The first department would accommodate an artillery experimental area supporting seven officers, fifty-one non-commissioned officers and seven men. There would

The clock tower complex at the old Shoebury Garrison.

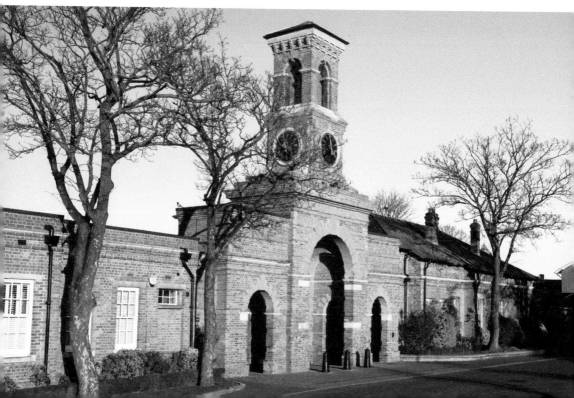

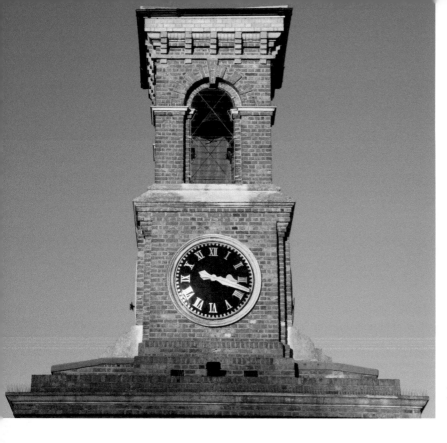

A close-up
view of the
clock tower.

be stabling for fourteen horses, a place for administration, a canteen, a hospital, a
powder magazine and a place for shell storage. In addition there would be a battery
for six guns and two mortars. Batteries were to be placed south of the old Coastguard
Station on its west side. Temporary accommodation would also be required for
Woolwich Barrack visitors needing to see the artillery experiments. The second area
would be for general training and would consist of accommodation for fifteen officers
and 122 men and non-commissioned officers. Stabling would be for sixteen horses.
There would be another administration area, hospital, etc., a further six batteries (two
of which will be on moving platforms) and four mortars. Work commenced on the
site during the summer of 1847. A total of £15,000 was made available to start the
project, although at the time the total cost was expected to run into £20,000 or £30,000
if all the work was realized. As artillery technology progressed, batteries had to be
redesigned and new ones incorporated into the site.

In 1852 the military presence at Shoebury was still expanding with its continuing
need to accommodate visiting personnel. During that year adverts were placed in the
Kentish Gazette inviting tenders for the building of a washhouse, soldiers' rooms and
a mess room.

Today many original buildings, such as the clock tower surmounting the archway to
Horseshoe Barracks, complete with adjoining offices and guardroom, still stand. The
hospital and the Garrison Chapel can also be seen. However, this is now a residential
area, so the old buildings are not open to the public and the Garrison Chapel is no
longer a place for worship.

Above: The Old Hospital at the Garrison, built in 1856, now residential property.

Below: The Garrison Chapel is no longer a place of worship but private property.

Garrison School of Gunnery

The School of Gunnery at Shoeburyness was founded in 1859 and was attended by Prince Arthur in 1868. At this time the school offered three courses: a long course, an intermediate course and a short course. The long course lasted for a year with a four-week break in the summer and time off at Christmas. The course was designed to accommodate fifty personnel, comprising twenty officers with the remainder being non-commissioned officers. The subject matter covered everything it was thought the artilleryman needed to know and was based on the artilleryman's handbook. The intermediate course was an abridged version of the long course. This was available to officers assisting more senior officers and for officers and sergeants of the Militia Artillery. The course was also open to other suitable persons if they could be spared from their normal duties. Each intermediate course lasted for around three months. The short course, however, lasted for a maximum of two weeks. It gave an overview of artillery matters with an emphasis on artillery drill. It was generally aimed at those who were on leave from duties abroad who would otherwise miss out on any rifled-gun tuition. In a sense this was a sort of taster course, without qualification, and is likely to have been the course Prince Arthur attended as his stay in Southend was of short duration.

From 1864 annual Artillery Volunteers competitions were held regularly on the site, which were attended by personnel from all over the country. Visitors would camp under canvas at what is now Campfield Road, just off of Ness Road. Campfield Road is the home of Shoebury's war memorial.

The powder magazine.

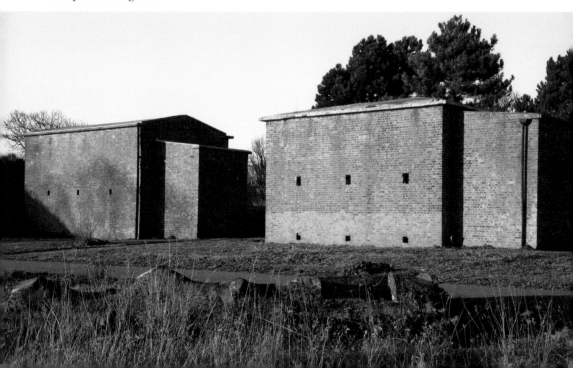

A twin experimental casement.

In 1891 the School of Gunnery was visited by Princess Mary Adelaide Wilhelmina Elizabeth (1833–97), the Duchess of Teck and granddaughter of King George III. She was accompanied by her husband, Franz Paul Karl Ludwig Alexander (1837–1900), the Duke of Teck, who had attended the competition once before. The princess presented the prizes to the winning contestants.

Gog and Magog

A short distance from the Coastguard Station and next to the Garrison Pier on its eastern side is the remains of Gogs Berth, which gets its name from the War Department barges *Gog* and *Magog*.

Magog was the first barge built, at a cost of £2,300, and measured 85 feet in length with a width of 27 feet. She was launched at the yard of Sturridge and Hartnell in Limehouse during September 1876. Her purpose was to transport the new 80-ton gun from Woolwich to Shoeburyness. To achieve this *Magog* had to be towed down the River Thames by two steam tugs at spring tide to ensure a high enough water level to place the barge at the gun landing area, of which there were two. The first landing place was on the eastern side of the artillery station where range and accuracy experiments were carried out. When the water level dropped the stern of the barge would be opened and the gun retrieved. After the range and accuracy experiments

29

Above: The remains of *Gog*'s berth viewed from the west side.

Below: A view of *Gog*'s berth from the north.

The Garrison Pier.

were completed *Magog* would carry the gun to the second landing place on the south-west side of the artillery station where targets would be fired at.

When the 100-ton gun with its twelve-wheel carriage was introduced, the *Magog* was considered too small to carry the load. This resulted in a second barge, *Gog*, being built. *Gog* measured 105 feet in length and 30 feet wide. It was launched by basically the same firm but now called Sturridge and Sons. The launch took place in November 1885 at their Fisher Wharf in Millwall. Because *Gog* was larger than *Magog* the same landing place could not be used, so a new berth had to be constructed. Unlike the 80-ton gun, when the 100-ton gun was required on the south-west side of the artillery station it was transported over land on the carriage.

The nearby Garrison Pier is a later construct, being completed in 1908–09. It was useful for receiving (and returning) weaponry and munitions from Woolwich, and occasionally Chatham.

Grove Terrace

Grove Terrace was a row of five brick dwelling houses built in the late eighteenth century between the Royal Library (which was sited opposite the Royal Hotel) and the later built St John's Church. The buildings spanned 135 feet in total on the south side and were positioned on a west to east line with No. 1 being the nearest house to the hotel and No. 4 the nearest house to the church. No. 5, known as Bellevue House, had

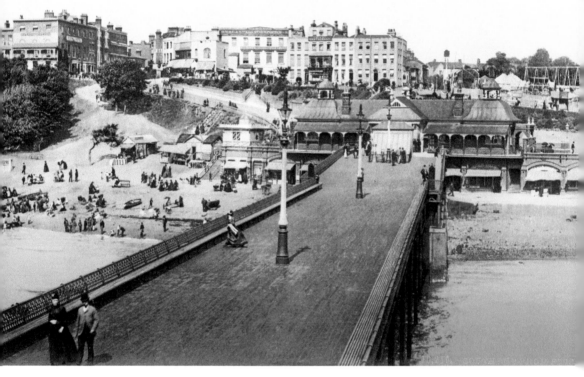

Right of centre is Grove Terrace *c.* 1898. (Courtesy of the Library of Congress)

bow windows and faced Grove Road. All the properties, however, ensured magnificent views of the Thames Estuary, the river traffic, the Kent coast and, with the possible exception of No. 5, views of the last rays of the setting sun.

Nos 3, 4 and 5 Grove Terrace once formed part of the Peter Denys estate, which is evidenced by the executors who put the property up for auction in 1836 with Bow Window House, after Lady Charlotte's death the previous year. The properties were bought by John Copland, a Chelmsford solicitor who had built up a sizeable property portfolio in Essex. A resident at Bow Window House during his period of ownership was Ann Lingood, and this may well be the same Ann Lingood who was a lodging house keeper later residing at No. 3 Grove Terrace and then at No. 4, until her death in 1861 at the age of eighty-eight. In October that year her furniture was auctioned and this included nine mahogany four-post, French, and other bedsteads, three loo tables, four mahogany chests of drawers, a mahogany wardrobe and other chamber furniture. There was also a set of mahogany dining tables with three shifting leaves to name only a few of the items for sale.

A further insight into the properties may be gleamed from No. 2 Grove Terrace, which was the tallest of the five properties (having four floors, whereas the others had three). It was also the only building with bay windows facing south. This breaks the

uniformity of the buildings, so on that basis Grove Terrace was not strictly a terrace. However, the additional height and bay windows are not discernible in a print dated 1810, so, if that drawing is accurate, these are additions to the original build. This part of Grove Terrace was occupied by Arthur Wilfred Bates as proprietor of the Pier Restaurant from the 1880s and it was later known as the Pier Hotel. In 1892 Bates wanted to open a shop at the front of the building and in order to do so he had three bay windows removed. These had stone dressings and the measurements inside were 6 feet 7 inches by 6 feet high. The windows were advertised for sale, as were two front doors with circular stone heads. Unfortunately, Arthur's wife died in August 1898 and shortly after her demise the property was put on the market to be let.

Meanwhile, W. G. Bagley, the managing director of the Southend and Essex Bill Posting Company, was using No. 4 Grove Terrace as a correspondence address in newspapers up to March 1899, which is likely to be when Nos 3, 4 and 5 Grove Terrace were demolished. A picture taken from Southend Pier, which is on the cover of Frances Clamp's *Around Southend* (Francis Frith) and attributed to have been done in 1898, shows a skyline with the absence of Nos 3, 4 and 5 Grove Terrace, but Nos 1 and 2 are still standing. The above perhaps indicates the correspondence address was not changed when it should have been, or perhaps the photograph was taken in early 1899.

In November 1899 Henry Choppin began advertising the Grand Pier Hotel in London newspapers, stating it had been entirely rebuilt. Certainly, the Grand Pier Hotel was built on the site of the old Pier Restaurant. However, when looking at a photograph of the Grand Pier Hotel taken by this author and published in *Southend Through Time*, it would appear the building had a longer façade than that of No. 2 Grove Terrace on its own, extending westward into the area occupied by No. 1. It therefore raises the question as to whether or not part of the original shell for both buildings was used in the construction of the new one, which would perhaps explain why both these buildings were left standing when the others were demolished. The old Pier Restaurant had four floors, whereas the Grand Pier Hotel had five, excluding any basements which may or may not have existed. Alterations were made to the Grand Pier Hotel in 1935.

Today the whole area is occupied by The Royals, a late 1980s built shopping centre with a multi storey car park on its eastern side.

Heygate Family

The Heygate name appears several times throughout this book, so it is perhaps necessary to give some background information about the coming of the Heygate family to Southend.

The first Heygate to arrive in Southend was James Heygate of the City of London who, in 1795, purchased the leasehold on the newly built No. 10 at what is now Royal Terrace. James was born in West Haddon, Nottinghamshire, on 11 January 1747, during the twentieth year of the reign of King George II (1746/47) and he was one of several children of Nicholas Heygate and Ann (Cooke). James was a hosiery manufacturer by trade and he was in partnership with a gentleman named John Pares.

On 11 January 1781 at Hackney, James married Sarah Unwin, the second daughter of Samuel Unwin and Elizabeth who resided at Sutton in Ashfield. Sarah and James had four children, three of whom would play an important role in the development of Southend. The first born was William, then James. Next there were two daughters, with each being named Elizabeth Ann, presumably after the mothers of each parent. The first Elizabeth Ann died in infancy. The second Elizabeth Ann was born in 1788. Each child was baptised at St Mary Aldermanbury in the City of London during the month following their birth.

In 1800 James Heygate and John Pares formed another partnership, but this time with John's brother, Thomas, and a fourth person. They traded as Pares and Heygate, a private bank based in Leicestershire. The business expanded and James managed the London branch until 1825 when the management of the branch was taken over by Isaac Hodgson. While working at the bank James began to buy further property in Southend, building a sizeable land and property portfolio.

James Heygate died at his then Southend house on 13 April 1833. His body was transported to the family vault at the Freehold Burial Ground, St Thomas Square, Hackney, where his remains were interred on 20 April. That was not his final resting place, however, for in 1898, by the instructions of a grandson, James Unwin Heygate of Southend, his remains were removed, as were those of Sarah who died on 2 February 1801 at the age of fifty-five. Their remains were transported to Nottinghamshire where they were reinterred at West Haddon. James Unwin Heygate, who was one

time in partnership with Edward Kilworth of Southchurch as a farmer and grazier until the partnership was resolved in 1846, was also interred at West Haddon, having died at No. 14 York Road, Southend, on 28 October 1907 at the age of ninety-two. He previously lived for many years at Porters Grange.

Heygate Sons

William Heygate was born on 24 June 1782. He was a Freeman of the Merchant Taylors Company and followed in his father's footsteps by joining the private bank of Pares and Heygate in 1813. William later entered politics, becoming a Member of Parliament for Sudbury, and he was the Deputy Lieutenant for Hertfordshire. He also served as alderman for the Coleman Street ward of the City of London and became Lord Mayor of that city for the 1822 to 1823 session. William thought the aldermen of the City of London had historically not received the recognition they deserved and so he applied for a baronetcy. In 1829 the Duke of Wellington (Arthur Wellesley 1769–1852), during his first period as prime minister, rejected William Heygate's application, but a baronetcy was eventually awarded to him in September 1831, during the premiership of Earl Grey (Charles Grey 1764–1845), partly influenced by William IV (1765–1837).

The Beta pier train *Sir William Heygate* at the station on the end of the pier.

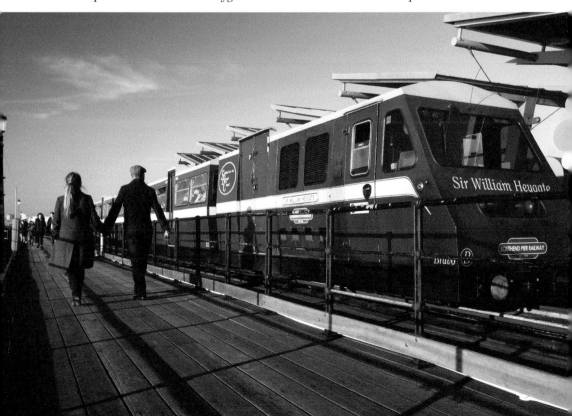

William Heygate lived for many years at the Royal Terrace when in Southend. Assisted by his father, brother and sister, he campaigned largely at his own expense for the building of Southend's first pier. His efforts are recognised with the Beta pier train being named after him. Sir William Heygate died on 26 August 1844.

William's brother, James Heygate (junior), the father of James Unwin Heygate, was born on 15 February 1784. Like his brother, James joined Pares and Heygate, but he had to resign on 14 September 1830 accused of misappropriating some of the bank's funds. He married Anna Macmurdo, and on the same day at the Prittlewell parish church, William married Anna's sister, Isabella. Elsewhere, and on a day prior to the double wedding, Octavia, a third sister, married Thomas Pares II. Thus, the Heygate, Macmurdo and Pares families were all linked by marriage.

Anna died on 9 September 1867. The following year her husband bought Porters Grange and some of the surrounding land for £5,000. James died on 22 July 1873. Anna and her husband are both buried in St Mary's churchyard, Prittlewell. There is a tomb there made from pink granite excavated from the Ross of Mull Quarries and designed by Charles Robert Baker King (1837–1916), a pupil and assistant of Sir George Gilbert Scott, RA (1811–78), who designed the Midland Hotel at Paddington station. A medieval-styled cross sits on top of a chamfered plinth, which is on the south side of the church near the entrance. There is a plaque inside the church on the north wall dedicated to Anna:

> *To the glory of God and in memory of Anna Heygate born on the Feast of the Purification of the Blessed Virgin Mary Anno Dm 1792 and who entered into rest September 9 Anno Dm 1867.*

Elizabeth Ann Heygate died on 19 January 1879.

The tomb of Anna and James Heygate at St Mary the Virgin, Prittlewell.

Hippodrome

The Hippodrome once stood in Southchurch Road near the Hotel Victoria, which itself stood on the corner of Southchurch Road and the High Street opposite where WHSmith is today. It was designed by William Robert Crewe, who also designed the London Opera House and the Belfast Hippodrome. Known as Bertie Crewe, he was born in 1863 at Romford Road, Stratford, and died of pneumonia on 10 January 1937 having caught influenza on New Year's Day.

The Hippodrome was opened in 1909 by Mayor James Colbert Ingram and could seat nearly 2,000 individuals, although if all the standing room was occupied some 3,000 persons could be accommodated. The entertainment venue attracted some top artists of the day, including the often-controversial Marie Lloyd (Matilda Alice Victoria Wood 1870–1922), who in later years was well known for her rendition of the popular Leigh and Collins song 'My Old Man (Said Follow the Van)'. Marie's performances were often considered to be risqué with her facial expressions, delivery of lyrics and exceptional timing open to double meaning. She was a frequent visitor to Southend and would often stay in the Alexandra Hotel at the west end of Alexandra Street. Her second husband and former boxer Alec Hurley (1871–1913) was a regular performer at the Empire Theatre in the same street. Marie and Alec were married in 1906 but divorced in 1910. The reason cited was Marie's alleged adulterous affair at a hotel in Nice, France, with the Epsom Derby-winning jockey Bernard Dillion. After the divorce was granted Marie and Bernard married.

Marie Lloyd often stayed here when it was the Alexandra Hotel.

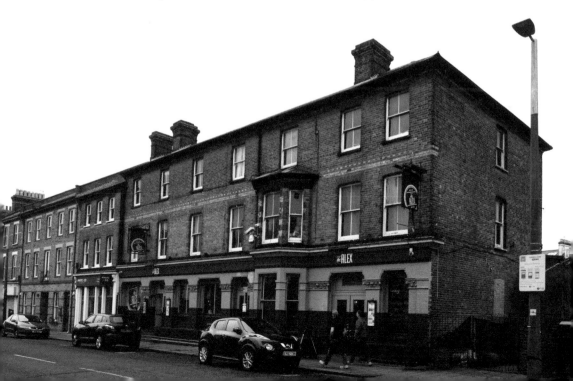

Many of Marie's songs were written by John Mitchell, who was a Southend and Westcliff resident. Before coming to Southend, John, who sported a moustache and enjoyed smoking cigars, was the proprietor of the Cock Tavern in Whitechapel. He married Eugenie (Bobby) Eliza Agnes Kate Roberts of the Cambridge Music Hall, Spitalfields. She was the daughter of Charles Roberts, a theatrical agent. John also wrote songs for Marie's husband, Alec Hurley, and died at Southend Municipal Hospital on 12 October 1944.

Other performers at the Hippodrome include Dolly Harmer (Dorothy Scott), the stage mother of wee Georgie Wood OBE. Georgie Wood is honoured with a mention in *Dig It* on the Beatles' *Let it Be* album – 'Can you digging by Georgie Wood ...'

Those who followed in the footsteps of Lloyd, Harmer and Wood were unable to tread the boards at the Hippodrome after 1934 as in that year the entertainment venue changed from a music hall to the Gaumont Cinema. Thus, plays and variety acts were replaced by movies. The building was demolished in 1958.

Hope Hotel

The Hope Hotel, which stands on what is now Marine Parade, was built sometime during the 1790s. It is said to have begun life as Capon's Coffee House. Certainly, a building of that name was trading by 1794 when the property of a Mr Sweeting was advertised in the *Kentish Gazette* as being auctioned on those premises. The operator of the coffee house may have been the same Mr Capon who, in 1784, conducted business at the nearby Ship Inn. In 1814, when George Kemp, the Hope Hotel's then owner, died, the building was marketed as a 'nearly-new erected mansion'. The mansion house we see today, however, is one that has been extended. The original building is the part which displays the balcony.

The Hope Hotel, a prominent building on Marine Parade.

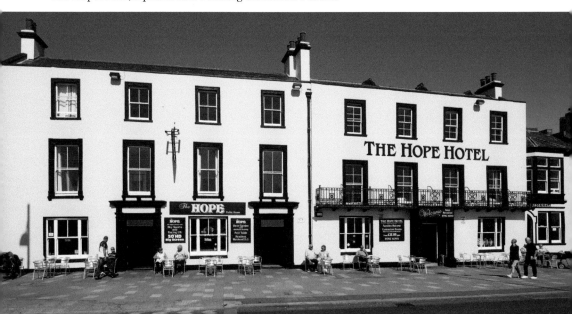

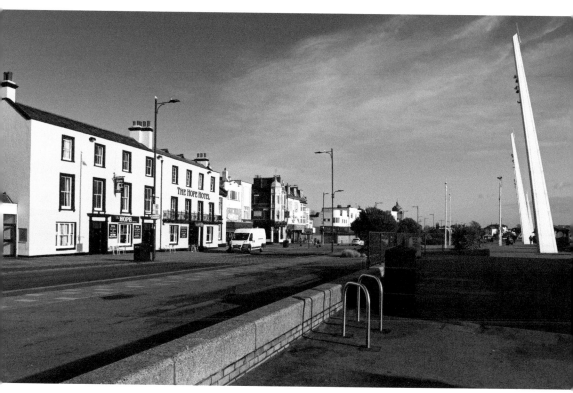

The old hotel stands opposite the modern lighting masts.

In 1868, when the existing licensee, John Brasier, retired, the licence of the Hope Hotel was transferred to Caroline Burroughs (Joscelyne), who was previously at the Bell Inn, Leigh-on-Sea, the harbour town where she was born. Her husband, who died in 1866, was Walter Burroughs, whose late father of the same name held the Fox Inn at Bury. It was during Caroline's tenue as licensee of the Hope Hotel that the extension to the original building was made. The first works were completed on 20 May 1871 when a new bar was opened on its west side. In June 1877 it was further announced in the *London Evening Standard* that the house has undergone 'extensive alterations and additions'. This included a new dining room facing the sea, which could accommodate 100 people. Behind the hotel was a meadow. In 1879 Mrs Burroughs received £4 compensation when eight of her swine were slaughtered after contracting swine fever. The next year she had eleven fowl stolen, which were never recovered. In 1881 the licence was transferred from Caroline Burroughs to William Middleton, who kept it until 1889.

Imperial Prince and the Empress of France

In October 1874, Southend was honoured by a visit from Eugenie de Montijo (1826–1920), the Empress of France. She was the widow of Napoleon III (1808–73), the nephew of Napoleon Bonaparte (1769–1821). The Empress Eugenie was in exile and living in Chislehurst, but she stayed at the Royal Hotel when her son, Napoleon Eugene Louis Napoleon Jean Joseph Bonaparte (or Prince Louis Napoleon Bonaparte, for short), was attending a course at the Shoebury School of Gunnery. The empress visited the Imperial Prince (1856–79) at Shoebury and, on one Wednesday evening, the prince visited his mother at the Royal Hotel where he joined her for dinner. Dinner was usually served at 7 p.m.

A few years later the Imperial Prince insisted on going to South Africa where the British had a desire to proceed deeper into Zulu territory. King Cetshwayo (1826–84) objected to the intrusion and pulled together some 60,000 warriors in an attempt to see off the British in what was the Anglo-Zulu war. The Imperial Prince, who was not on his horse at the time, was in a small group that came under attack from several Zulus. It would appear no one came to the prince's aid and a Zulu warrior threw three assegias at him. These are hardwood spears with an iron tip, which the warriors carried in a quiver. Other attacks on him followed resulting in several wounds to his body. The wounds included two to the chest, severing two arteries. There was another wound to the eye, which pierced the brain. His body was brought back to England and laid to rest at the Chapelle Ardente, Camden Place. Queen Victoria, a friend of the Empress Eugenie, attended his funeral and she mentions the event and the wounds he received in her journal.

The prince was initially interred at St Mary Chislehurst, but his body and that of his father were later removed to St Michael's Abbey, Farnborough, which is also the last resting place of Eugenie, who founded the abbey as a mausoleum.

The one-time occupant of Southend's Royal Hotel has an asteroid named after her. Eugenie 45 is a 213-kilometre main belt asteroid that orbits the sun on a path between the orbits of Mars and Jupiter. In 1998 it was discovered to have a companion. The 13-kilometre satellite was named the Petit Prince.

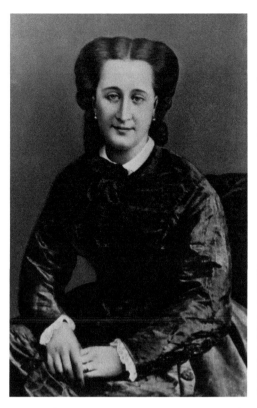 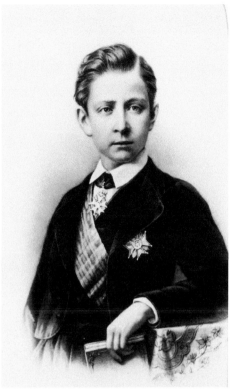

Above left: Eugenie de Montijo, the Empress of France, stayed at the Royal Hotel. (Courtesy of the Library of Congress)

Above right: The Imperial Prince, Prince Louis Napoleon Bonaparte. (Courtesy of the Library of Congress)

Iron Gates

The green-painted, wrought-iron gates at the entrance to Priory Park were a gift from Southend's well-known benefactor Robert Arthur Jones. These gates were designed by the architect Philip Mainwaring Johnson FSA, FRIBA (1865–1936), who was the brother of the explorer Sir Henry Hamilton Johnson (1858–1927), after whom the Johnson Falls on the River Luapula are named. Philip, however, is probably best known for having been appointed the resident architect for Chichester Cathedral and he had designed more than twenty war memorials. A keen archaeologist, especially architectural archaeology, he was a member of the Sussex Archaeological Society, lecturing on the subject of archaeology far and wide.

Philip's gate designs were worked on by John Starkie Gardner FGS, FSA (1844–1930), who had ironworks at Tradescant Road in South Lambeth, London. John was the son of John Edmund Gardner, a chandler and lamp manufacturer. As well as making

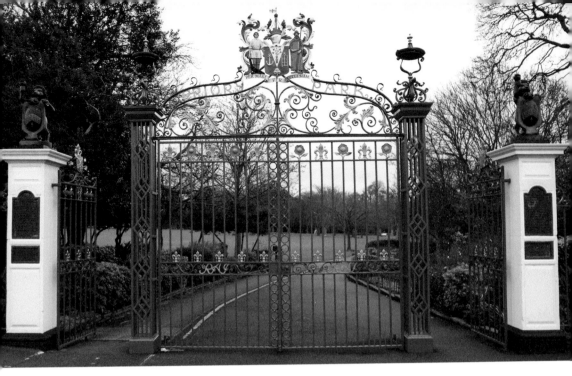

Above: The iron gates entry point at Priory Park.

Left: The old village water pump near the iron gates at Priory Park.

the gates for Priory Park, John Starkie Gardner was commissioned to make a set of gates at Holyrood House, Edinburgh, for Edward VII (1841–1910). He was also a keen palaeontologist. In February 1876, for whatever reason, he appears to have sold his entire collection, offering numerous fossil fishes and reptiles to the Natural History Museum (British Museum) for £150. These specimens were collected from layers of gault, greensand and chalk laid down during the Cretaceous period.

Just south of the gates is an old Prittlewell Village water pump that has recently been restored and painted a light blue. Between the iron gates and the water pump is Prittle Brook, which joins the River Roach at Rochford.

J

Jones, Robert Arthur (MBE)

For nearly thirty-five years, Robert Arthur Jones was a Southend watchmaker, jeweller and optician. He is probably best remembered, however, for his purchase of Prittlewell Priory and the surrounding land, which he gave to the council for the benefit of Southend residents.

Robert was born in the Everton district of Liverpool on 20 November 1849 and was baptized there at the Church of St Augustine (which was attached to the parish of Walton on the Hill) on 1 September 1850. He was the third son of John and Catherine (Price), who were married just over ten years earlier on 11 February 1838 at St Brides, Liverpool. John Jones was a native of Holywell in Flintshire and, like his father, Edward, was a watchmaker. Robert was to follow in his father and grandfather's footsteps, beginning his watchmaking career in 1862.

Some sixteen years after his watchmaking career began, Robert married Emma Julia Pedley, the youngest daughter of Theophilus Pedley, who was an engraver. The marriage took place on 2 February 1878 at the parish church of Stoke-on-Trent. Robert and Emma had two children: Edward Cecil and Arthur Percy. Both children were born in the same parish in which their parent's married.

It was in 1890, however, that Robert moved with his family from Stoke-on-Trent to Southend and he purchased the watchmaking business of Alexander Wixley at No. 3 High Street. Wixley moved often and left Southend for Great Yarmouth. The building in which Wixley and Jones traded was named the Clock House, but later it became known as Jones's Clock. By this time the High Street had been extended to accommodate the approach road on the north side; the numbering system changed, and No. 3 High Street became No. 76–78 High Street, now occupied by the women's fashion retailer Yours. During those early days Robert also traded from the Pier Pavilion. When Robert began trading he sold American Waltham Lever watches, as did Wixley before him. These watches were manufactured in Massachusetts, USA.

To encourage early trade Robert advertised special offers. One such offer was to give each customer spending £5 or more a copy of Rudyard Kipling's Transvaal War Poem accompanied by other items. He paid the *Daily Mail* newspaper 1 shilling for

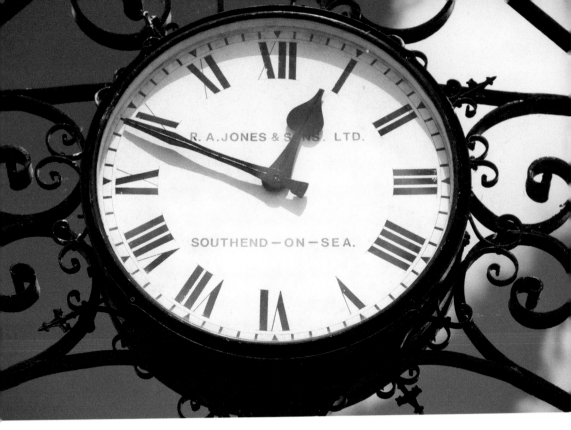

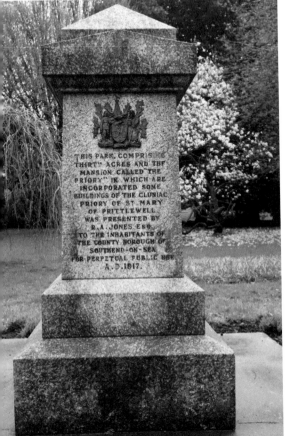

Above: The R. A. Jones clock at the south entrance to Prittlewell Gardens.

Left: A stone commemorating the giving of Priory Park for the use of the people.

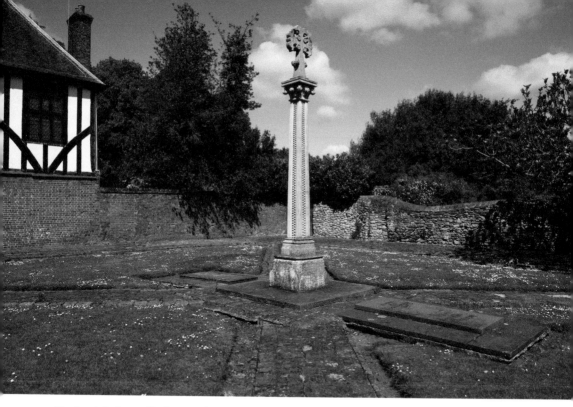

The burial place of Robert Arthur Jones at Prittlewell Priory.

each copy, the proceeds of which went to the relief fund to help the children of the soldiers engaged in the Transvaal War.

Robert quickly established himself at Southend and as profits rolled in he launched the R. A. Jones Challenge Shield for local school football teams to play for. There were other small gifts, but the value of gifts increased considerably after Emma died in 1912. Before her death she suggested renaming Southend Thamesmouth, and campaigned for that name to be adopted, but did not succeed. Emma's funeral was at the Sutton Road Cemetery with the Revd Frances Dormer Pierce officiating at the service. It was five years later, in 1917, when Robert bought Prittlewell Priory. Other gifts included the Jones Memorial Recreation Ground and the Victoria Sports Ground.

Robert Arthur Jones MBE, an Honorary Freeman of Southend, died on 23 May 1925. A service was held at St John's Church but his funeral took place at the Cloister Garth, Prittlewell Priory, and was attended by the Bournemouth Park Road School choir. He was laid to rest beside the stone cross which he is said to have funded in memory of the Cluniac monks. His son, Edward Cecil Jones MBE MC JP, who succeeded Robert in the jewellery business, is also buried there. A memorial stone for Robert can be seen on the west side of the cross. A memorial stone for Edward is on the east side. Two years after Robert's death an oak chancel screen designed by Sir Charles Nicholson FRIBA was erected in Robert's memory at the Church of St John the Baptist.

Residents of Southend must be truly grateful for Robert's generosity in giving them the priory and park. Without his generosity there is little doubt this haven for wildlife and place of leisure would have been lost to building development.

Kursaal

On 1 August 1894 a new park was opened in Southend on land owned by the solicitor Alfred Tolhurst and his son Bernard Wilshire Tolhurst. The Marine Park comprised some 15 acres of land on which was built a bandstand and a dancing platform on springs measuring 15,000 square feet. There was also a 2-acre lake. A cycle track of just under a third of a mile soon followed. This enclosed 4 acres of land, which was used for the playing of sports such as cricket and football. The whole park was designed by Henry Ernest Milner (1845–1906), a civil engineer and landscape gardener. The lease was held by Henry Austen. Austen had proposed the building of a pavilion on the

The Kursaal is now a Grade II listed building.

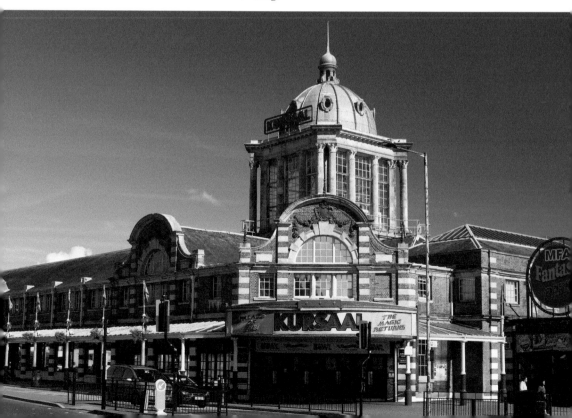

site and he applied for a drinks licence, which he thought would help increase trade, but due to opposition, mainly from the Women's Temperance Movement, the licence was refused. Tolhurst and son were somewhat incensed by this and indicated they would dispose of the land for building development. In 1896, however, the land was acquired by the Pyramidical Syndicate Ltd. The syndicate planned to expand the site with the purchase of additional land and to develop the place as a premier park for amusements and entertainment. During the same year some of the directors formed the Pyramidical Railway Company to run what was basically a conical iron structure where a train would ascend to the top by a lift at the centre and then descend on an outside spiral path. The railway was designed by William Darker Pitt, who first proposed the idea of the Blackpool Tower, which was opened in 1894.

The venue was later taken over by the Southend-on-Sea Tower and Marine Park Company, which was formed in December 1897. All of its activities were privately funded. However, after a short period of time the business changed its name to the Margate and Southend Kursaals Limited, seeking a public listing. The company issued a prospectus inviting the purchase of ordinary shares and preference shares with a total value of £175,000. This public offering lasted for two days only. The purpose of raising the funds was to develop sites for amusement and entertainment not only at Southend, but at Margate too. One of the directors of the company and the appointed chairman was the Portugal-born Sir Henry Hoyle Howorth (1842–1923), a Conservative MP for Salford South.

At Southend, the site to be developed then comprised 26 acres of land on a lease of ninety-eight and a half years with an option to purchase at a later date. Horse trotting races had been introduced to the park. As well as the pavilion suggested by Austen, it was proposed a building comprising a dining area, bars and places offering ordinary refreshments would be built. Billiard rooms were also proposed, as were twelve shops fronting the main building. A further sixty shops were to be built in an arcade leading to an Eiffel Tower that would accommodate a circus at its base. Work based on the plans and designs of R. J. G. Reed (the principal engineer to the Blackpool Eiffel Tower) and the architect George Campbell Sherrin (1843–1909) had already begun before the public offering, with the building work being undertaken by Abram Kellett of Willesden. Not all of the 26 acres were required by the company for its entertainment and amusement facilities, so it was proposed the additional land would be used for the erection of fifty-three houses and a further twenty-seven shops.

On Wednesday 24 July 1901 the general public were able to walk into the octagonal entrance hall and stand under the 60-foot-diameter dome for the first time, before making their way to the Kursaal Hippodrome, which housed a water tank for aquatic displays. Lord Claud Hamilton (1843–1925), chairman of the Great Eastern Railway Company, arrived at Southend on a special train from Liverpool Street in order to open the building. Less than two years later, on 2 March 1903, an extraordinary meeting was held and the Margate and Southend Kursaals Ltd was voluntarily liquidated. The Eiffel Tower did not materialise. The company's plans to emulate Blackpool as

a place for amusement and entertainment was too ambitious based on Southend's population and demographic. The Kursaal was put up for sale. In March 1910 the newly incorporated Lunar Park and Palace of Amusements (Southend) Limited advertised it had taken over of the property. At this time the property was named Lunar Park. The appointed managing director was T. W. Hilton. That company, too, was quickly dissolved, which may have been partly due to a fierce fire in 1911 where an electrical fault that began in the Haunted House spread to the Joy Wheel, causing much damage, although the rest of the park was quickly operational again.

In 1912 at the Southend Borough Petty Sessions the drinks licence was transferred from Mr Hilton to the American promoter Clifton Jay Morehouse, who had taken over the property. Clifton arrived in the UK in 1897 having been born at North Blenheim, New York State, in 1859. Morehouse was ambitious, but within realistic limits. He made many changes and appears to have been quite successful until his death in 1920. However, in 1914 his ambitions were disrupted when the Kursaal grounds were taken over for military training. In that year (Sir) Joseph Austen Chamberlain (1863–1937), a Chancellor of the Exchequer and half-brother of the later Prime Minister Arthur Neville Chamberlain (1869–1940), held a soldier recruitment campaign at the Kursaal. On Clifton's death his son, David De Forest Morehouse (1883–1935), took over the running of the business. On David's death the running of the business remained in the family.

There have of course been many changes since 1935, which space will not allow to be discussed here, but the Kursaal building, with its iconic dome, still stands and is now Grade II listed.

L

Lifeboat

On Thursday 13 November 1879, Edwin John Brett presented to the town of Southend its first purpose-built lifeboat, which was stationed at the end of the pier. The fair-haired, blue-eyed Mr Brett, who also sported a fine moustache, was born in Canterbury, Kent. He worked as an engraver, but later became a publisher, launching *The Boys of England*, a journal he used for raising funds for the Southend lifeboat.

After Edwin officially handed the lifeboat over to the Royal National Lifeboat Institute (RNLI), it was ceremoniously named *The Boys of England and Edwin J Brett.* A celebratory luncheon was had at the Royal Hotel. Present at the luncheon were members of the committee formed to manage the lifeboat for the RNLI and this was chaired by the Revd Frederick Thackeray, then vicar of nearby Shopland and a cousin of the novelist William Makepeace Thackeray.

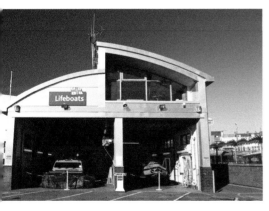

Above: The Lifeboat House on shore.

Right: The Lifeboat Station at the end of the pier.

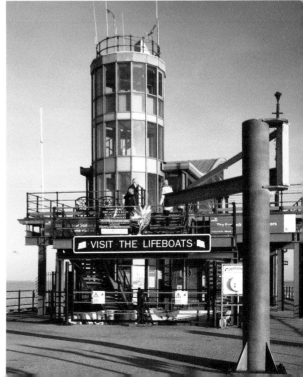

The RNLI later presented Edwin with a model of the lifeboat and this he proudly displayed in the smoking room of his main residence at Burleigh House on the Camden Road, Holloway. Edwin's main hobby, however, was the collection of armour, which he purchased all over the UK and the Continent. This he also proudly displayed in his north London home.

Southend officially launched its second lifeboat on 8 October 1885. Mrs Thackeray, the wife of Revd Frederick Thackeray, did the honours. The boat was built by Woolfe and Son of Shadwell. It had a width of 7 feet 6 inches and was 34 feet long, longer than the boat at the pier. The cost of the lifeboat was bequeathed to the RNLI by Frances Sophia Smith (1808–83), the daughter of the Revd John Emanuel Orpen and widow of William Smith, a barrister. Frances was a resident of Lisheen, County Cork, and died at the Adelaide Hospital, Dublin, on 6 April 1883. The lifeboat was named *Theodore and Herbert* after her only two children who both died at a young age.

After the cost of the lifeboat had been deducted from the monies available there were sufficient funds for a building to house it and this was built in Harlington Street.

Today there are four lifeboats at Southend. Two lifeboats are based in a purposely built building on shore at the east side of the pier between the pier and Adventure Island. These are a D class inflatable and the hovercraft. Another D class lifeboat and a B class are based at the pier head.

Lifeboat – First and Second Coxswain

The first coxswain appointed by the Southend Lifeboat committee was a Southend-born fisherman, George Myall. He served on the lifeboat *The Boys of England and Edwin J Brett*. George was for many years an agent for Lloyds and in later life he was a coaching house keeper, living at No. 1 Marine Parade where he had an oyster shop. His second wife, Mary Jane, whom he married on 11 October 1853 at St John's Waterloo, was born in Margate, Kent. She was the daughter of John Jenkins, a mariner who also served on lifeboats. The sea claimed the life of John Jenkins as well as Mary's half-brother, Henry Richard Brockman, who drowned when serving on the *Friends of All Nations* lifeboat based at Margate. George Myall held the position as coxswain for only a few months, however, as in May 1880 another coxswain was appointed. George died on the 10 November 1906 at the age of seventy-nine and is buried in St John's churchyard, as is his wife, who was a resident of Southend for nearly sixty years.

The second lifeboat coxswain – and often referred to as the first – was John Frederick Moore, a member of the lifeboat crew from the start. He was a waterman and pleasure boat proprietor. Like George, John was born in Southend. He held the position of coxswain for nearly twenty-seven years, resigning in April 1907 due to health reasons. He lived out his last days at No. 20 Marine Parade. This well-respected

and fearless seaman saved many lives during his lifeboat career, attending 150 or so wrecks. John served on *The Boys of England and Edwin J Brett*, the *Theodore and Herbert* and the 1899-launched *James Stevens No 9*. On hearing of his death at the age of fifty-eight on 6 April 1910, the captains of many boats small and large flew flags at half-mast as a mark of respect.

There is a monumental inscription in the grounds of St John's Church where John Frederick Moore is buried. It is sited across the path to where the George Myall gravestone is, almost opposite. Also mentioned is his wife, Elizabeth Watts Moore, who died on 25 June 1921. Another name included on the stone is their son, Harold James Moore. Harold was on board the requisitioned HMY *Iolaire*, which was being used to transport sailors home after the end of the First World War. During the early hours of New Year's Day 1919 the yacht hit a rock at the Beast of Holm near Stornoway harbour on the Isle of Lewis. Although the collision happened less than 100 yards from shore, there was a force 8 gale at the time and 201 men drowned, including Harold. Sixty-four bodies were never recovered. There were seventy-nine survivors.

Below left: The George Myall headstone at St John the Baptist churchyard.

Below right: The John Frederick Moore headstone at St John the Baptist churchyard.

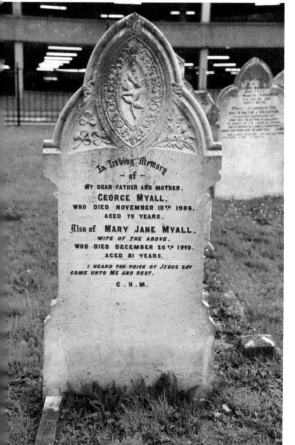
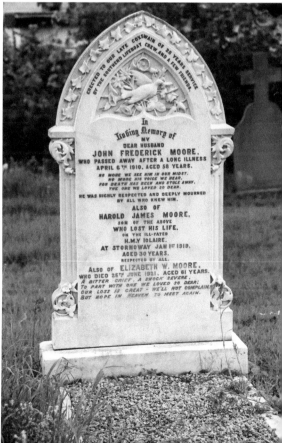

Metropole Hotel (Park Inn)

The early history of what is now the impressive building of the Park Inn Palace Hotel is a rather complex one plagued by debt and legal issues. Suffice to say it began life as the Metropole Hotel, the build having commenced in 1896 and was completed in 1901. It was not fully occupied then and for over three years remained empty. Therefore trading did not really begin until the formal opening on Monday 23 May 1904 when a ball was held on the premises for 500 guests.

The hotel included an American bowling alley, Turkish baths and a billiard room with four tables. There were close to 300 apartments. It cost £300,000 with a staircase alone costing £5,000. The hotel generated its own electricity from three 160-horse

The Metropole Hotel, now the Park Inn Palace Hotel.

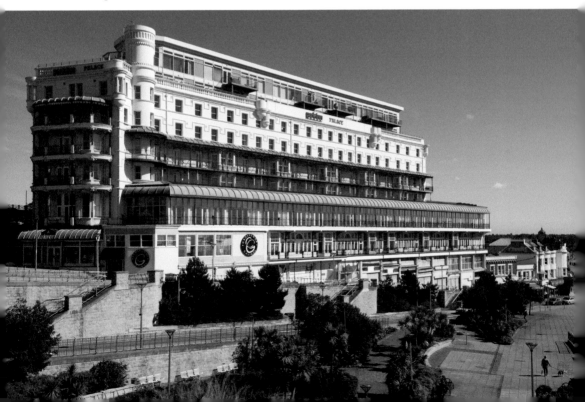

power boilers. The main entrance was on the west side with a smaller entrance on the north side, which was used by guests arriving by carriage.

The hotel building is made of Portland cement and was based on designs by the West Hartlepool-born James William Thompson, then a resident of St Vincent's Road, Southend. In 1900 a hack on the *Islington Gazette* was not impressed with James's design of the then unfinished building, which was being built in the Scottish Baronial style. He wrote, 'It has a curious set of tunnelled towers at the summit which remind me of salt and pepper boxes.' The base of these 'salt and pepper boxes' can still be seen today, the tops having been removed.

The year 1900 was also the time of a dreadful accident when Frederick Lyford, a nineteen-year-old plasterer working from the building scaffolding, fell nearly 60 feet to his death.

Debts continued to accumulate for those connected with the hotel and in December 1904 there were new owners who changed the name of the hotel to the Palace Hotel in January 1905.

During the First World War the hotel became the Queen Mary Hospital and in the summer of 1915 there was a private visit by Princess Louise, the Duchess of Argyle (formerly Marchioness of Lorne), who toured the wards and spoke to the injured soldiers.

Today this historic building has 137 guest rooms, a fitness centre, a casino and seven meeting rooms. Now named the Park Inn Palace Hotel, it comes under the Park Inn Raddison Hotel brand, which is a part of the Raddison Hotel Group.

National School, Prittlewell

The old National School building in East Street, Prittlewell, on the south-east side of the church dedicated to St Mary the Virgin, was formerly opened on Tuesday 26 May 1868 by the Bishop of Rochester, uncle to the Revd Spencer Robert Wigram, the then vicar of St Mary's. It is made of Kent ragstone with Bath stone dressings and is built in an ecclesiastic style. It sits on the site of the old vicarage and its foundations include bricks from a wall that was erected when the Revd Charles Americ Belli (1791–1868) was vicar from 1816 to 1822. The Revd Belli, brother-in-law to the Bishop of London, made a contribution to the fund for the school even though he had left Prittlewell many years before. It was the Revd Belli, incidentally, who married William Heygate to Isabella Macmurdo at St Mary's in 1821.

Adjoining the school is the dwelling house, which downstairs had a living room, scullery and kitchen; upstairs were four bedrooms. The house was occupied by George Bigsby, the schoolmaster, who lived there with his wife Emma, his mother and his sister. George's wife and sister were teachers at the school. Whereas the church is set back from the road, the old National School is close to the pavement, separated by a stone wall, and even today is a prominent fixture near the west end of East Street.

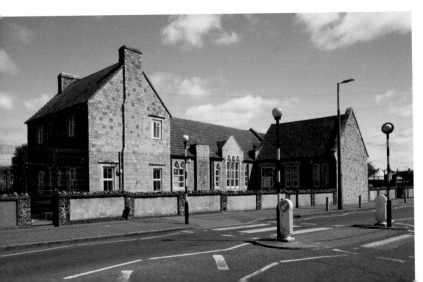

The old National School building in East Street, Prittlewell.

O

Operation Dynamo

In June 1940 six boats from Leigh-on-Sea took part in the evacuation of Dunkirk: *Defender*, *Endeavour*, *Letitia*, *Reliance*, *Renown* and *Resolute*.

One of these vessels can been seen anchored at Old Leigh near the western end of the High Street. The 30-foot-long cockle boat *Endeavour* is London registered and carries the alphanumeric identifier of LO41. There is an information stand nearby which states that in 2001 the boat was found in Kent. It was in very poor condition but restored under a trust formed by Leigh residents. There were financial contributions from individuals and the project was further supported by several grants. The information stand further states the *Endeavour* has since revisited Dunkirk, accompanied by other boats and a Royal Navy escort.

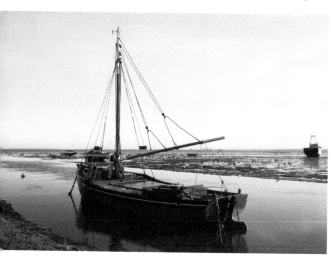

Above: One of the six boats from Leigh that took part in the Dunkirk evacuations.

Right: A memorial to the four men who died assisting the Dunkirk evacuations.

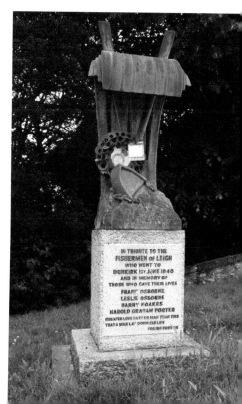

Unfortunately, however, not all the boats from Leigh returned safely from the Dunkirk evacuation. On 1 June 1940 the *Renown*, owned by Messrs Osborne Bros, hit a mine. The Leigh fishermen Frank Osborne, Leslie Osborne and Harry Noakes were all killed. An eighteen-year-old naval rating and signalman attached to HMS *Safeguard* was also on board. He was Harold Graham Porter from Birmingham. There is a memorial to all these men in the graveyard of St Clement's Church at Leigh. Harold's name also appears on the Chatham war memorial in Kent.

In January 1948 another cockle boat was named *Renown* to replace the one that was so tragically lost. This larger boat, some 40 feet in length, was launched by Catherine Logan, a twelve-year-old daughter of Southend's Medical Officer Dr James Stevenson Logan.

Our Lady of Lourdes and St Joseph

The desire to promote the Catholic faith at Leigh-on-Sea began in earnest when Cardinal Bourne, the Archbishop of Westminster, appointed Father J. J. O'Neill to the cause in 1913. A temporary church was built and this was replaced by the building of

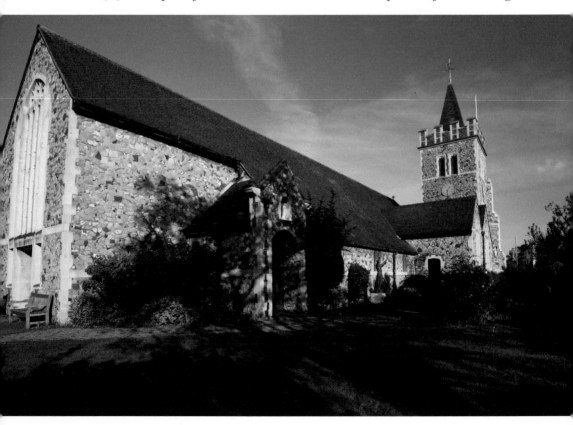

Our Lady of Lourdes and St Joseph at Leigh.

A memorial
to Joseph and
Frances Calnan
at Our Lady of
Lourdes and
St Joseph.

a new church dedicated to Our Lady of Lourdes and St Joseph. The new church was designed by the London-born Cannon Francis Walter Gilbert (1875–1952), who was at Grays before his arrival at Leigh. The foundation stone for the new church was laid in 1924. The church was completed the following year. On completion Cardinal Bourne preached there and the church was blessed, but it was not consecrated until 1929 when the Bishop of Brentwood, under whose diocese the church falls, officiated at the ceremony. A replica of the Grotto of Lourdes was built in the Lady Chapel by a church member who was an engineer. Mr Psaila did the work and he is likely to have been Cyril Psaila who later became a photographer at Leigh. At the top of the church tower a weathervane was erected and this represents the fourteen-year-old peasant girl Bernadette Soubirous, who had a vision of the Virgin Mary at Lourdes on 11 February 1858.

P

Pier

In the late 1820s a bill to construct a pier at Southend as a replacement to the jetty was put to the House of Commons and then referred to the House of Lords, where, at its third reading on 7 May 1829, it was approved. Royal Assent followed on 14 May and on 27 June the Southend Pier Company placed an advertisement in the *Morning Advertiser* inviting tenders to supply the building materials. This comprised ninety oak trees, thirty of which were to be 24 feet long and sixty to be 30 feet long. Each

The pier entrance *c.* 1898. The smoke is coming from the fire to heat the baths. (Courtesy of the Library of Congress)

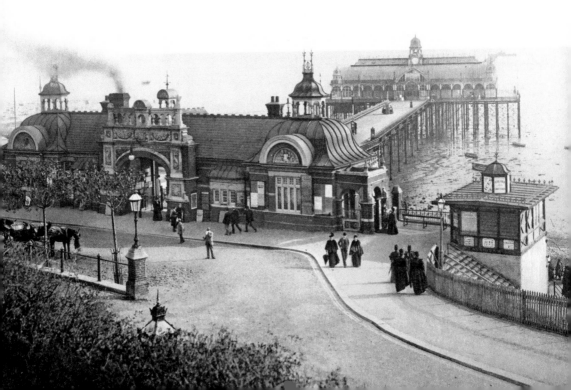

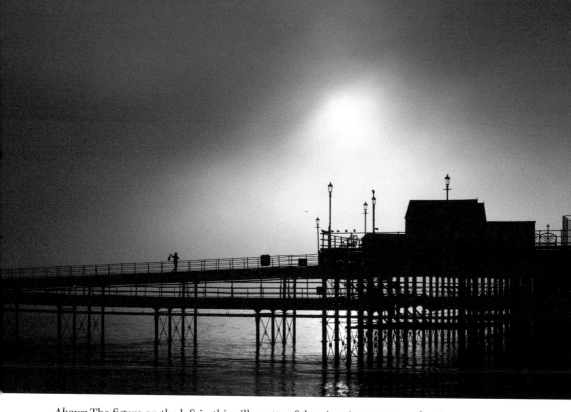

Above: The figure on the left in this silhouette of the pier gives a sense of scale.

Below: The old bell marks the end of the pier.

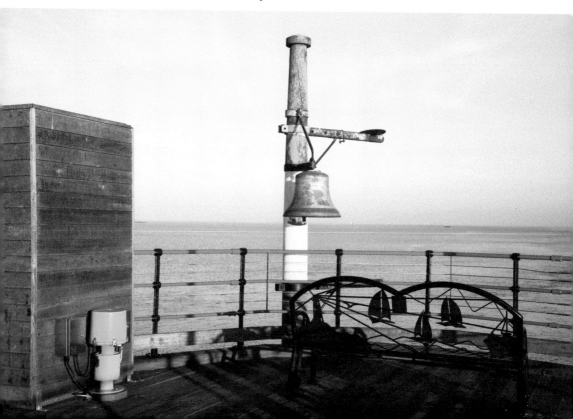

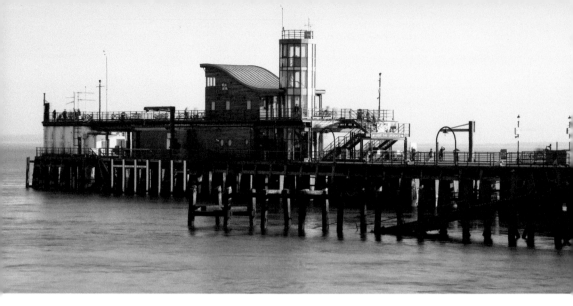

Above: The pier head with the Lifeboat Station tower.

Left: The shore end of the pier from the west side.

length was to have a 1-foot diameter. Also required was a quantity of Memel or Dantzic timber. Less than one month later, on 25 July, the foundation stone for the pier was laid down by the then Lord Mayor Sir William Thompson (1792–1854). By June 1830, 600 feet (by 20 feet) of the pier had been completed and another 200 feet was near completion. In September the pier had extended some 1,500 feet out to sea. Even so, it could only be used at high tide.

However, not everyone thought the pier was a welcome addition to Southend. In 1833 Harriett Renneson of the Royal Library wrote to Lady Elizabeth Langham stating the pier had done the town no good. The widow Lady Langham held property at the Terrace, which she was trying to sell. One of these properties, No. 10, was bought by her late husband, Sir James Langham, from James Scratton, who held it on a sixty-six-year lease. Three years later Renneson again wrote to Lady Langham stating the town had declined every year. In succeeding years, however, the old pier, which had been extended to 1 ¼ miles, in 1846, had given good service. In 1875 the Southend Local Board purchased the pier.

In 1887, four years after Lloyds opened a signal station there, it was considered time for the old wooden pier to be replaced with one where the main structure was made of iron. During the same year a tragic accident occurred.

Kesiah Musson Little (Hill), who was born at Wimborne, Dorset, in 1831, left her home at Colliers Cottage on the Enfield Highway at around 6 a.m. to catch a train to London. When she arrived at London with two of her daughters, she saw an advertisement for excursions to Southend, one of which she decided to join. Just after midday she was walking along the pier when a tramcar driven by Edward John Ingram came towards her. The tram consisted of two horses, a trolley and three cars. Within a few yards of the ladies one of the horses broke a plank on the deck of the pier, stumbled one way, and, in order to avoid being hit by the horse, Kesiah moved the other way, but tripped over a rail and was unfortunately run over by the trolley and one of the cars. Dr George Davidson Deeping attending the incident said Kesiah suffered a broken skull (which killed her), a smashed jawbone, a broken left thigh and several minor injuries. One of the daughters, Mary Ann, went to her mother's assistance and unfortunately suffered several injuries, including to her thigh, which was dislocated. Mary Ann was rushed by train to Guy's Hospital in London. William Little, a bookkeeper at the Royal Small Arms Factory, Enfield Lock, was informed of the death of his wife by telegram. Many people enjoy their visits to Southend, but 29 August 1887 was a very sad day for the Little family.

Less than one year after Kesiah's death tenders were opened for the newly proposed pier. The new iron pier was built alongside the old wooden one. On 1 August 1890 a new electric tramway, replacing the horse tram, was tested, and on the following day, a Saturday, the rail system was open to the public. The Pavilion on the pier was partly open on Sunday 3 August 1890, its roof and tower made of Vielle Montagne zinc mined at Kelmis in the Province of Liege, Belgium.

Surprisingly, there was a mortuary under the old pier which remained on that site after the new pier was built. In 1898 complaints were received regarding the stench experienced by people passing by and from individuals trading near the pier. Fortunately, the mortuary is long gone.

The new tramline was partially destroyed just before Christmas 1898 when the yacht *Dolphin* dragged anchor and collided with the pier.

The pier has been damaged many times since then, through fire or collision. Fortunately, however, Southend is still home to the longest pleasure pier in the world. In the UK it covers nearly twice the distance of its nearest rival, which is at Southport in Lancashire.

Porters Grange

Porters Grange is a delightful late fifteenth- or early sixteenth-century building. It gets its name from Lawrence le Porter, who held the land at the very beginning of the fourteenth century, if not just before. His son, Laurence De Gardino, who took part in local affairs,

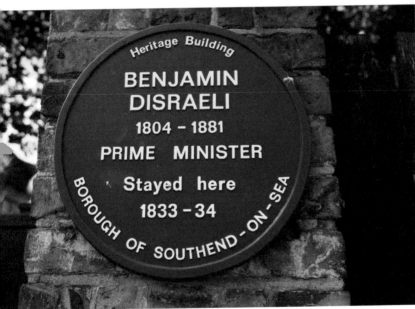

Above: A west-side view of Porters Grange.

Left: The plaque commemorating Benjamin Disraeli's visit to Porters Grange.

Heritage Building

BENJAMIN DISRAELI

1804 – 1881

PRIME MINISTER

Stayed here

1833 – 34

BOROUGH OF SOUTHEND-ON-SEA

may have taken over the property on his death. Through sale and inheritance, however, it eventually passed to one Josiah Thwaites, a mariner of Stepney, and remained in that family by inheritance until the estate was split into ten lots with the building being purchased by James Heygate junior. The sequence of events is an interesting one. When Captain Josiah Thwaites died the property passed to his widow, Judith, who later married Sir Edward Leighton. Dame Judith's daughter, also named Judith (Thwaites), married

Sir Robert Clifton. Lady Clifton, in her will, passed the property on to her cousin, Mary Purvis, a resident of Harwich. Mary's eldest son, Barrington, married Amy Laetitia Colville, the daughter of the Revd Nathaniel Colville DD. Barrington inherited the estate and his and Amy's only child, Frances Laetitia Philippa Purvis – who married Edward John Francis Kelso, a Captain in the 72nd Highlanders – inherited from them. Frances died in 1873, but the Porters Grange mansion was put up for sale before then, in 1868, which is when James Heygate junior bought it.

The Heygate family, however, had lived at Porters Grange for many years, although on one item of correspondence James Heygate junior gives his address as Porters Grange Cottage, which is likely to have been the Macbearer's cottage. The Heygates probably moved into Porters Grange in 1833 when the property was put up to be let. However, an occupant with James Unwin Heygate in 1841 was Longdon Macmurdo. His brother, Edward Macmurdo, was a school friend of the later to be Prime Minister Benjamin Disraeli (Lord Beaconsfield). Disraeli visited Porters Grange in 1833 and 1834. There is a plaque outside the building on one of the brick gateposts commemorating Disraeli's stay. Another visitor of note was Princess Louise, the Marchioness of Lorne, who, in 1873, visited Porters Grange to have an early tea with James Heygate junior. The royal party was entertained by his sister, Elizabeth.

Prittlewell Priory – a Short History

In AD 910, a modified Christian order based on the following of St Benedict established itself at Cluny in the Burgundy region of France. The abbey of St Peter and St Paul was visited by William de Warenne (who was with the Duke of Normandy at the Battle of

Above: Looking towards the north wall of the refectory at Prittlewell Priory.

Right: The old doorway in the north wall of the refectory.

Hastings) and his wife Lady Gundrada. Both were impressed by the religious order of the Cluniac monks there and, having the desire to establish a monastery in England, they set about founding a first English priory of the Cluniac order at Lewes in Sussex. William de Warenne, who had acquired land and property at the Conquest, gave the Saxon church of St Pancras to the Cluniac cause with the first prior being appointed in 1077. More priories were later established by William and others, with eight of these cells coming under the auspices of the priory at Lewes, one of which was at Prittlewell.

It is not known for sure when Prittlewell Priory was established. It is possible a monastic following of sorts began at the Saxon church on the site of the present church of St Mary the Virgin, giving a foundation for a priory, as did the Saxon church at St Pancras Lewes. There is, however, no monastic activity listed in the Domesday Book of 1086, although land was being farmed at the Manor of Milton, and at Sutton, to help meet subsistence needs for the monks at Holy Trinity in Canterbury.

At the time of the Domesday Book, Robert Sweyne, son of Wimarc, was Lord of the Manor of Prittlewell. It was Sweyne's son, also named Robert, who gave what appears to be a priory (rather than just land) to the abbey at Lewes. The first mention of a priory at Prittlewell, which was dedicated to the Blessed Virgin Mary, appears on a document dated 1121. This means the priory is likely to have been established sometime during the thirty-five-year period from 1086 to 1121, but probably during the early years of the reign of Henry I (1100–35). The year 1110 is a date often cited, but a distinction needs to be made between the date of the original build and the giving of the priory to the Cluniac order, which is not necessarily the same. Robert senior died in 1114, so it would make sense if an existing priory (possibly built 1110) was given to the Cluniac order by his son at that time, or shortly after. If so, Prittlewell Priory would have been founded as the fourth priory of the Cluniac order under St Pancras Lewes.

Once established, however, Sweyne gave the tythes of the Hamlet of Middleton (Milton), the chapels of Eastwood and of Sutton to Prittlewell Priory. He also gave several churches to the priory, including the church at Prittlewell and at Wickford. The chancery roof at Wickford, incidentally, is said to have been built with an oak beam taken from the refectory of Prittlewell Priory.

The first known prior at Prittlewell was William, who was there in 1203 and as late as 1226. John de Monte Martini was a later prior, but by the deed of Bertrand, the minister of the church of Cluny, he was appointed prior of Lewes in 1307, to fill the gap left by Stephen de Sancto Romano, who was promoted to prior of Beaulieu-en-Argonne, France. John's replacement appears to have been Henry de Fautrariis, who was there for just over a year. John stayed at Lewes until his death in 1324. It is likely to have been during John's period as prior that in 1302 eighteen monks were attached to the priory. Often there were fewer, with fourteen monks in 1279. The then prior, who appears to have been another William, was having the church at the priory rebuilt. What appears to have been the original church was built during the reign of Gilbert Foliot as Bishop of London (1163–87), for he campaigned to raise funds for a church

building at Prittlewell Priory to be completed. Gilbert, incidentally, was a monk at the Abbey of Cluny when in his late teens.

In 1343 Henry de Suthcherche, an illegitimate son of the local Sir Peter de Suthcherche, was admitted as a monk to the order of Cluny at Prittlewell Priory. The last prior to serve at Prittlewell was Thomas Norwiche.

Writing in volume 2 of his *Repertorium & or an Ecclesiastical Parochial History of the Diocese of London (1710)*, the historian Richard Newcourt, who became a Proctor General of the Court of Arches and the principle registrar for Diocese of London of which Prittlewell was a part, informs us that following the Dissolution of the Monasteries and during the twenty-ninth year of the reign of Henry VIII (1537/38), the land on which the priory stands was granted (28 May 1537) to Sir Thomas Audley, the Lord Chancellor, to be held for the king until his death. Sir Thomas died in 1544, before Henry VIII who died in 1547. By the time of his death Thomas had acquired a substantial estate, much of which was in Essex, but the priory is not mentioned in his will. Audley's brother, also named Thomas, appears to have acquired the priory in 1539, and by licence obtained from Edward VI during the fifth year of his reign (1551/52), transferred the property to Richard Lord Rich, who was Lord Chancellor to Edward VI from 1547 to 1552. Lord Rich died in 1567 at nearby Rochford. Rich, by his grandson, Robert Rich, was an ancestor of the Earls of Warwick through which the estate passed, Robert being the first earl. The hereditary male line eventually died out and it was left to three heiresses, whose husbands disposed of the property. The land was acquired by Daniel Finch, Earl of Nottingham, in 1673. His first wife was Lady Essex Rich, the daughter of Robert Rich, 3rd Earl of Warwick. Daniel appears to have sold the property to Daniel Scratton of Billericay in 1678, although the priory has the date of 1675. The Scratton family held the property for nearly 200 years.

Several members of the Scratton family are buried at St Mary's Prittlewell. There is, for example, a plaque for Robert Scratton (d. 1839) and his wife Elizabeth (d. 1840) inside the church. Some members of the family are interred at Broomfield, Chelmsford.

Daniel Robert Scratton put the property up for sale in 1869 when he moved to Devon and bought an estate there. John Burness of Leytonstone was the next purchaser and he sold it to William Keys who later resided at Southchurch Hall. In 1874 the property was sold again and this time it was acquired by John Farley Leith QC, one-time MP for Aberdeen. Leith died in 1887 and his grave is in front of the outside east wall of St Mary's Church. There is a plaque for him on the wall inside. The property was then back in the hands of the Scratton family with William Howell Scratton being the purchaser. Edward Joshua Blackburn Scratton, a cousin of Daniel Robert Scratton, died there in 1916. Finally, during the First World War (1917), the priory and lands were purchased by Robert Arthur Jones, who gave the property to Southend Council for the use of the people of Southend. The grounds in which the remains of the priory stands were officially opened as a park to the public in 1920 with the then Duke of York doing the honours. The property was restored two years later and a museum was opened. The property was restored again and completed in 2012.

Left: The east wall of the refectory.

Below: The walled garden north of the priory.

Above: One of two ponds fished by the Cluniac monks which are still fished today.

Below: The south wall of the refectory.

Queen Victoria Statue

It was during a town council meeting on Wednesday 10 March 1897 that Mayor Bernard Wilshire Tolhurst formerly proposed that a statue of Queen Victoria be sited overlooking the seafront at Southend. His proposal was accepted and during a fine afternoon on Tuesday 24 May 1897 he, as the then Alderman and Deputy Mayor, presented the statue to the town. It was of course Queen Victoria's seventy-eight birthday. The statue was unveiled by Lady Rayleigh (1846–1934). She was met at Southend Victoria railway station and the carriages of dignitaries made their way to Pier Hill where the statue was sited. The route was decorated with bunting and

The Queen Victoria statue was moved to this site in 1962.

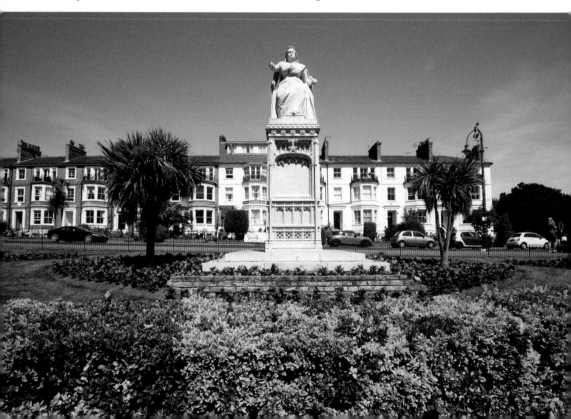

lined with people. Lady Rayleigh (Evelyn Georgiana Mary Strutt (Balfour) was the wife of John William Strutt (1842–1919), the Lord Lieutenant of Essex. He was one of the discoverers of the inert gas argon and, in 1904, was awarded the Noble Prize for Physics. Lady Rayleigh was also the mother of the physicist Robert John Strutt.

Unfortunately though, Lord Rayleigh was unable to attend the presentation of the statue, which was based on designs by the architect Edward Goldie (1856–1921). His father and grandfather were also architects. Edward Goldie made his name primarily in designing churches for the Roman Catholic faith. One of his constructs is St James's Church in Marylebone, London. Like St James's Church, the pedestal and throne on which the statue of Her Majesty sits is in the Gothic style. On the top of the backrest is a coat of arms. The statue and plinth are made of Carrara marble, which is quarried from the city of the same name in the Tuscany region of northern Italy.

The sculptor of the statue was Joseph William Swynnerton (1848–1910), a resident of Rome for several years. However, Joseph was born on the Isle of Man and that is where he died. He married Annie Louisa Robinson ARA, the first woman to be elected to the Royal Academy. Among her works was a portrait of the feminist and suffragist Dame Millicent Garrett Fawcett GBE (1847–1929).

In 1962 the Queen Victoria statue was moved west to its present site at Clifftown Parade and sits within its own little garden, bordered by hedging and a short fence.

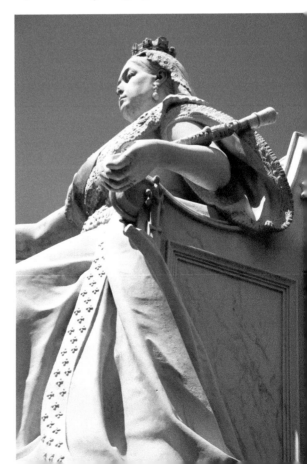

A close-up view of the Queen Victoria statue from the east side.

Royal Hotel

The Royal Hotel was formerly the Grand Hotel and sits on a prominent clifftop position where Pier Hill meets the High Street. It was built in the late eighteenth century, with work commencing in 1791. The roof was completed in early 1792 with the grand opening in 1793.

The leaseholder in those early years was Thomas Holland, a builder and chapman. Holland entered bankruptcy in 1795 with the furniture being auctioned two years later. The hotel, however, was very much considered to be a going concern, and when it was put up for auction in 1800 with other leasehold properties, it was marketed as a capital building, thus a capital hotel.

The next leaseholder appears to have been Daniel Miller for he held the lease for around thirty years until his death on 4 December 1831. During his tenure the property was locally referred to as 'Miller's Hotel'. Daniel did not live in the hotel but in a property opposite that had its own garden. When Daniel's estate was auctioned in 1832, a 13-foot billiard table was among the items listed for sale. Also listed were bottles of sherry that had been in the bottle for nine years and 200 dozen bottles of port, some of which had been in the bottle for fifteen years. Seven horses and a pony were put up for auction, as were four items of artillery on carriages. Also included were buildings of rentable value, but these are too numerous to mention here. During those early days Nos 1 and 2 Royal Terrace were part of the hotel with a walkway joining the three properties.

Daniel's son, also named Daniel, appears to have taken over the business in the early 1820s, or at least assumed some of the responsibility for running the hotel, but his time in charge was short-lived. During the spring of 1825 he mounted a colt, ignoring the advice of the horse keeper who told him not to ride with a curbed bridle. The colt, who had thrown the horse keeper the day before, became agitated on reaching the white gate separating the New Southend private road from the public roadway, reared up, and fell hitting its head on Daniel's head with fatal consequences for Daniel.

The hotel was often used for formal gatherings and dancing, which would go on until the early hours of the morning. Such balls were attended by members of high society. In 1801 a ball was attended by the Dowager Marchioness of Headfort. In 1807

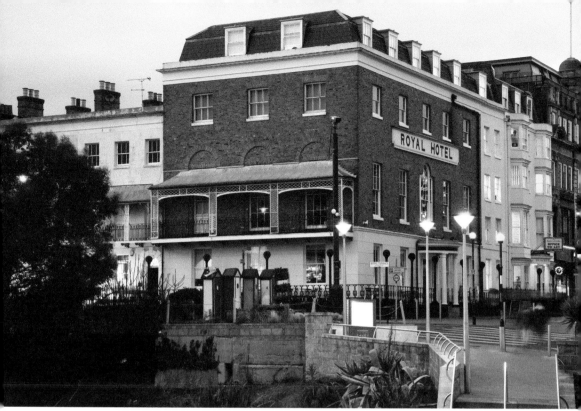

Above: The Royal Hotel was completed in 1793.

Right: A portrait of Prince Arthur, who stayed at the Royal Hotel in 1868. (Courtesy of the Library of Congress)

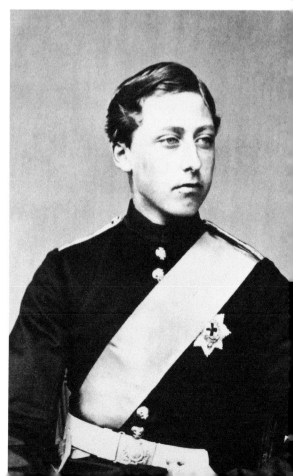

attendants were Sir Thomas and Lady Wilson, Baron Thomson, Sir William with Lady Beechey, Lady Wood and the Dowager Lady Trafford. In 1837 it was the Marquis and Marchioness Clanricarde, Sir Stratford and Lady Canning. Also attending was Lady Elizabeth De Burgh, Lord Dunkillen and Lady Sophia Tower. In addition, Lord and Lady Sidmouth stayed at the hotel for one night on 12 July 1834. Queen Victoria's son, Prince Arthur, stayed at the hotel for several days too, when he was attending gunnery practice at the Shoebury Garrison in 1868. Each day during his stay he would take an early morning walk in the shrubbery before going to the artillery school.

Royal Terrace

Royal Terrace runs west of the Royal Hotel and gets its name from a visit by Princess Caroline of Wales (Caroline of Brunswick), the wife of the Prince Regent, later King George IV. Princess Caroline stayed at the terrace for the 1804 summer season, arriving in May and leaving in October. She occupied Nos 8 and 9, using No. 8 for dinning purposes and No. 9 for sleeping, as did her dresser, Charlotte Sander. A little short of room, the princess later acquired the second-floor drawing room of No. 7, which could be easily accessed from No. 8 by use of the second-floor balcony.

Princess Charlotte, the daughter of the Prince Regent and the Princess of Wales, visited Southend for the summer season in 1801, but she stayed at The Lawn in

The Royal Terrace was built in the 1790s.

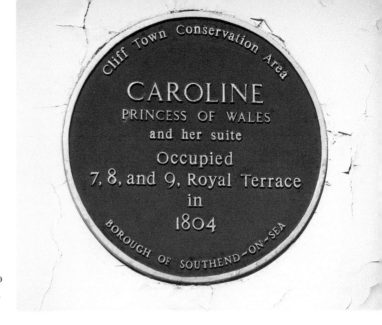

A commemorative plaque to Caroline, Princess of Wales, at the Royal Terrace.

Southchurch. She was a lively child who would acknowledge everyone she met, sometimes with a curtsy or by kissing the back of her hand.

In 1805, the year after the Princess of Wales occupied the drawing room at No. 7, the building was occupied for the summer season by Lady Emma Hamilton and Horatia, the daughter of Admiral Lord Nelson. Lady Hamilton enjoyed, and much benefitted from, the bathing Southend had to offer. During August 1805 Lady Hamilton held a ball in the assembly room at the nearby Royal Hotel in honour of Lord Nelson who, two months later, was to be killed at the Battle of Trafalgar. Nelson, of course, would have passed Southend's shores on more than one occasion and members of his family are said to be buried in the grounds of St John the Baptist Church.

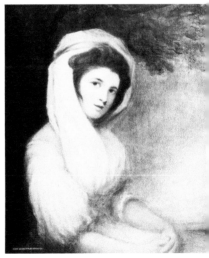

Above left: No. 7 is named Hamilton House after Lady Hamilton.

Above right: Lady Emma Hamilton as 'Daphne'. She stayed at the Royal Terrace. (LOC)

St Clement's Church, Leigh

Leigh church was built on a hill some 100 feet or so above sea level, overlooking the old fishing village and the River Thames. It serves the Anglo-Catholic tradition and is constructed primarily of Kent ragstone. The church is dedicated to St Clement, the patron saint of mariners, whose symbol is the Anchor of Hope. It is possible a church existed at Leigh since before the Conquest for one newspaper journalist who visited the area wrote in 1840 'whose tower has borne the blast for more than 800 winters'. That would put the building of a church at Leigh before 1040. The tower he saw, however, was in the main part the one we see today, which was built in the late fifteenth or early sixteenth century, so it had only seen half the winters stated. One wonders where the 800 came from, though. At the time of his visit the church had just been restored under the Revd Robert Eden, so perhaps details about the church were discovered during the building process but have since been lost. The oldest document this author is aware of which states there is a church at Leigh is a grant between

Below left: St Clement's Church, Leigh-on-Sea, viewed from the south.

Below right: The Calvary war memorial in the churchyard of St Clement's, Leigh.

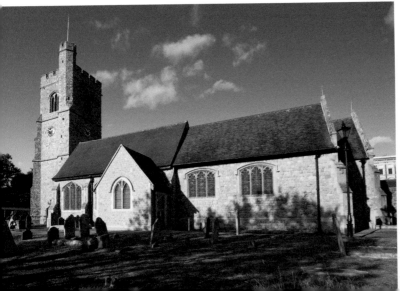

Stephen Le Brewere and Walter, son of Walter Le Wodeward, dated 1285. Another document dated twenty years later states Ralphe de Cokethorpe is the parson. Ralph de Cokthorp (spelling variation) is shown on the Rector board as being the rector in 1308. This author wonders if he is the same person as Ralphe de Cotthorpe who is on the Rector board at St Mary's Prittlewell for 1323. The Rector board at Leigh begins at 1248 with Andrew.

The western tower of the Leigh church has for many years been an important landmark for passing mariners who use it as a navigational aid. In 1897 the flag turret on the south-east side of the tower was badly damaged when the church was struck by lightning. The belfry suffered, too, as did three stained-glass windows in the church. The ivy that covered the north side of the tower at the time was badly burned but grew back only to be permanently removed in the early 1930s. The total cost of the lightning strike was estimated to be £1,000 at the time.

St John the Baptist Church, Southend

The building of an episcopal chapel for the inhabitants and visitors of Lower and Upper Southend was finally decided on during a meeting held at the Royal Hotel on 27 September 1832. The Lord Bishop of London, who was in the chair, donated £100 to the cause, which was matched by Amy Laetitia Purvis, the then widow of Barrington Purvis of Lawshall, who held Porters Grange. Both donations were exceeded by James Heygate with a donation of £105. Sir William Heygate donated £52 10s. Other donations were received on the day.

To raise additional funds for the church a three-day fete was held on the pier during the last week of July 1833 with a further £309 14s 6d collected, even though the exact

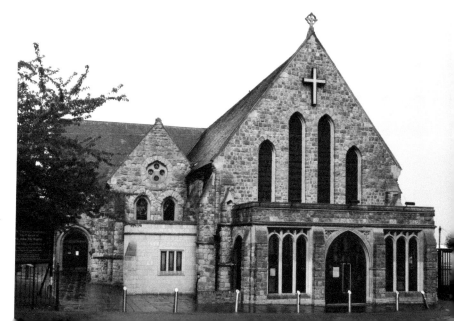

Southend's parish church from 1842 as seen from the west.

site of the chapel had yet to be determined. Lady Heygate assisted on one of the stalls. Another fete was held in 1840 when £216 11s 4d was raised.

The original church, which is made primarily of Kent ragstone, was built on a base in the shape of a cross. The consecration ceremony was conducted by the Bishop of London on 24 July 1842. At the time, General Strutt presented to the church a communion table made from a cedar tree grown in his park. He also gave the church a communion plate.

In June 1869 the Maldon-based contractor Ebenezer Saunders oversaw the completion of a north aisle and a south aisle was completed by the end of the year. In 1873 the same contractor completed the chancel, which was opened in April. Further work was done in 1906 when the church was extended westwards by 20 feet and the nave was reroofed. The year 1912 saw further improvements with the lengthening of the chancel and a new side chapel was erected. Other work was done on the church during these four dates.

The Bishop of St Albans officiated at the consecration ceremony for the enlarged 1912 building. Dr Randall Davidson, the Archbishop of Canterbury, was in attendance. On arrival he was greeted by the then vicar, Francis Dormer Pierce (1869–1923), who was previously the vicar of St Catherine, Wickford. It is perhaps worth mentioning a little about Dormer Pierce here.

In 1907, the year before his Southend appointment, Dormer Pierce visited his sister in Canada and by a special invitation he visited Wickford, Rhode Island, USA, to preach a sermon in the church at that place, which was founded by the family of former residents of Wickford in Essex. The church, the oldest in the US, was holding its 200th anniversary.

After St John, Dormer Pierce was appointed vicar at St Mary Virgin, Prittlewell, so he served at two churches within the Southend Borough. He was also president of the Southend Rugby Football Club from 1911 to 1914.

In 1912 the Revd Dormer Pierce was chairmen of the reception committee that greeted Princess Louise, the then Duchess of Argyll, when she visited Southend to open an extension to the Victoria Hospital. Before leaving Southend the duchess attended a service at St John's Church where she had previously worshiped. After his appointment to Prittlewell (1914), the then Cannon Dormer Pierce was appointed vicar of Brighton. Unfortunately, on Sunday 2 December 1923, he was late for a morning service at his church and ran to catch a tram, which he caught, but then collapsed when on board. He was taken to Preston Circus Police Station where he died. He was interred at West Blatchington cemetery.

St John the Baptist has its own burial ground. A large section of the graveyard north of the church was donated by John Rumble of the Royal Terrace in 1870 and was consecrated by the Bishop of Rochester on 25 July that year. There is a plaque commemorating the donation on the north wall (west side) of the churchyard. John Rumble is buried in the churchyard and there is a memorial to him on the north side.

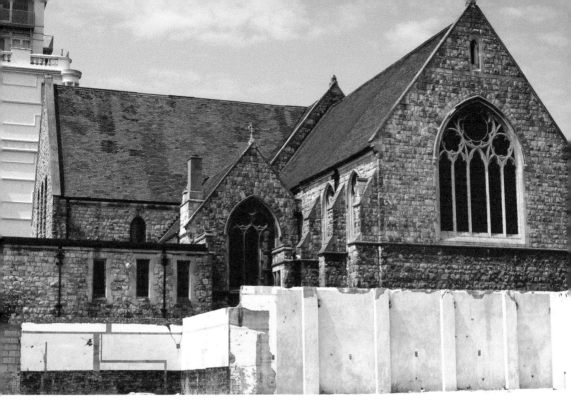

A view of St John the Baptist Church seen from the east.

St Mary the Virgin Church, Prittlewell

This magnificent church at Prittlewell, dedicated to St Mary the Virgin, stands on land which has been a place of worship for over 1,300 years. Its genesis was perhaps during the seventh century as a small Saxon chapel doorway of that date is incorporated in the north wall of the chancel of the present building. The original chapel is likely to have been a prominent feature of an early Saxon settlement. In 2003 archaeologists excavated land at the bottom of the hill on the north side of the church and discovered a late sixth-century burial of a high-status Saxon individual, often referred to as the Prittllewell Prince. Artefacts from the site are on display at Southend Museum.

Of the present church the nave is of Norman construction, having been built during the eleventh century. The building was added to in the twelfth and fifteenth centuries with the tower completed in 1478, or thereabouts. It is perhaps worth mentioning the vicar in the late eighteenth century was Sir Herbert Croft LLB (1751–1826), best known for his novel *Love and Madness*. He was a friend of Lady Mary Hamilton (Walker), a Scottish novelist, and he lived his later years with her as a friend in France. The Rector board begins in 1323 with Ralphe de Cotthorpe.

The church tower was restored in the early 1870s, as was the chancel roof. Spencer Robert Wigram was the vicar during the restoration.

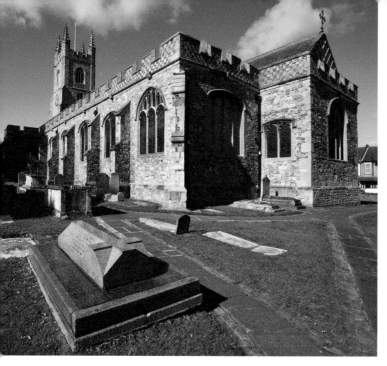

Above left: St Mary the Virgin, Prittlewell, with the tomb of T. O. Reay in the foreground.

Above right: Top right-hand side of the blocked Saxon doorway in the north wall of the chancel.

Below: Inside the church at St Mary the Virgin, Prittlewell.

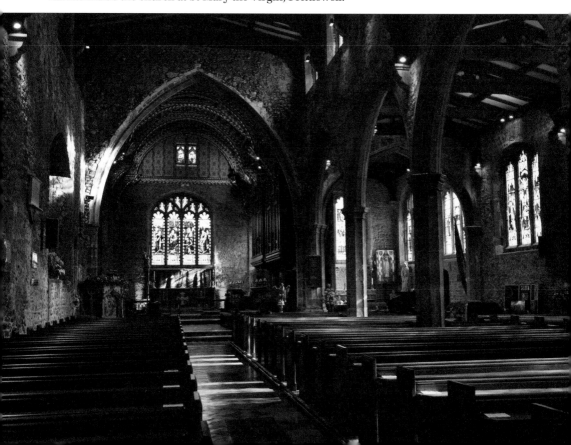

Spencer was born in Walthamstow, Essex, on 2 August 1835, he being the son of Octavius Wigram. He was educated at Harrow and later Oxford where he received his BA and MA degrees. Spencer was appointed vicar of Prittlewell in 1864. Three years later he travelled to Frome-Selwood in Somerset to marry Elizabeth Pearson Dalby. The couple served Prittlewell church until 1880 when they moved to Oxford. Spencer died in Hertfordshire in 1909. During his tenure as vicar of St Mary Virgin, Queen Victoria's daughter, the Princess Louise, who was staying at John Weston's the Lodge, worshiped at the church (1873) with her husband, before catching the afternoon train home.

On Spencer's departure Thomas Osmotherley Reay was appointed vicar, his tomb being a prominent feature on the south-east side of the church building. Thomas was born on 24 January 1834 at Mark Lane (a short distance from where Fenchurch Street railway station now stands) in the parish of All Hallows Staining, City of London. Educated at Eaton and receiving his degrees at Oxford, he was the son of John Reay, a wine merchant, and his wife Jane. Thomas married Alice Julia Harriott Borradaile, the daughter of John Borradaile, a chairman of the National Bank of India. Thomas was a keen sportsman and loved his cricket. He played for Marylebone Cricket Club (MCC) in 1853–56. On his death he was succeeded at the church by Francis Dormer Pierce.

Strand Wharf

For several centuries Strand Wharf was the main trading hub for the port of Leigh. Richard Chester, who was Master of the Corporation of Trinity House in 1615, lived at

Strand Wharf, Leigh.

The Old Customs House, High Street, Leigh.

the south end of the wharf, on its east side. The building was demolished shortly after the Second World War.

In 1832 a well was built near that property to supply the old town with fresh water. The water was discovered at a depth of 240 feet and was used to replace the existing reservoir at the lower end of the town, which had served the community for around 120 years. The work on the new well was carried out by Samuel Purkiss, with the project largely financed by Lady Olivia Bernard Sparrow, Lady of the Manor and a benefactor to various causes countrywide.

On the north end of the wharf, across the High Street, is the Old Customs House, built in the early nineteenth century during the reign of George III. It is now a private residence.

There has been a Customs House at Leigh since at least 1713 when the customs officer was Thomas Smith, who also held the position of Vice Admiral of Essex. A later officer was John Bright (d. 1756) and William King. King died in 1786 and was buried at St Clement's Church on 9 January that year. William held in freehold sea grounds, fishing grounds and oyster shores known as Prittlewell Priory and Milton Hall. His son, William Henry King, was also a customs officer.

The Customs House would often hold sales of the goods seized. This would usually be several hundred gallons of brandy, cognac and genever. In 1773 added to the list were 40 gallons of rum and 241 pounds of green and bokea tea. In 1787 1cwt cocoa nuts was sold and also on the list were sixty deer skins.

T

Trains on the Pier

The first electric railway on Southend Pier was opened in 1890. Colonel Rookes Evelyn Bell Crompton CB FRS (1845–1940), a Faraday Medal recipient (1926) of Chelmsford, played a leading role in its building and introduction. One of the early trains, or 'toast rack trains' as they are often called, can be seen at the Southend Pier Museum. The toast racks were replaced by four new trains in 1949 at a cost of £99,100. Each train had seven coaches and were described in the *Daily Herald* as a 'green and gold caterpillar'. The train would take its passengers from the shore to the pier head where they could enjoy a cup of tea at the Solarium, Beacon or Galleon cafés, before

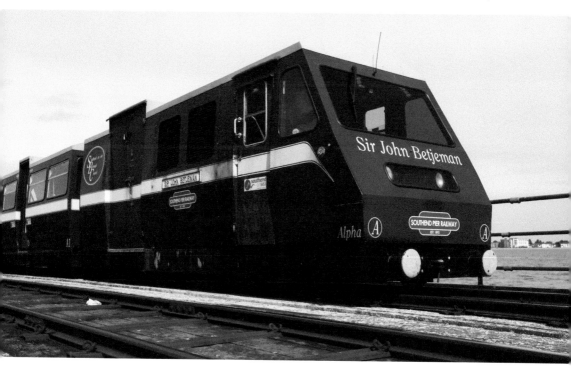

The *Sir John Betjeman* pier train parked at the loop.

Alpha

A side-on view of the *Sir John Betjeman* power car.

listening to the sounds of Ben Oakley and his orchestra. At that time there was a double railway track. That changed in 1986 when the old trains were replaced by two new ones. The Alpha train is named *Sir John Betjeman* and the Beta train *Sir William Heygate*. They operate on a single track that has a passing loop at around halfway. These trains, too, are about to be replaced at a cost of £3.25 million as part of a £14 million pier upgrade. There is also a single-car train that can be used to carry the public during quite periods, or to carry materials from one end of the pier to the other. The walkway, however, is also wide enough to accommodate a small vehicle, which is also sometimes used for maintenance purposes.

U

United

Southend United Football Club, or the 'Shrimpers' as they are also known, was formed in 1906 at the Blue Boar public house in Prittlewell, which stands at the corner where West Street meets Victoria Avenue. There is a blue plaque commemorating the event on the east wall of the building. The team began playing football across the road from the pub at Roots Hall Field, land which the club acquired on a seven-year lease. This was ideal for it accommodated 6,000 spectators with room for an additional 500 in a seated grandstand. Roots Hall itself was a private residence and for a few years the home of Daniel Wright Gossett, the second mayor of Southend. It was demolished to

The Blue Boar is where Southend United Football Club was founded in 1906.

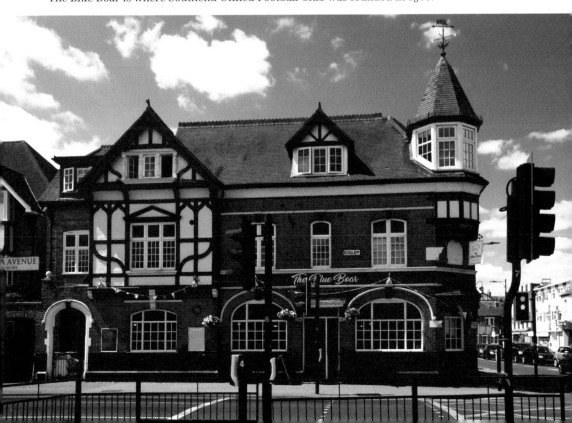

make way for the road. Oliver Trigg was the licensee of the Blue Boar when Southend United was formed and he was one of the original non-remunerated directors of the club, which was incorporated in August with an issue of 8,000 x five shilling shares, raising £2,000 of capital. Trigg was previously a hotel manager for his father at the Ship Hotel on Marine Parade. The club had already been accepted to play in the second division of the Southern League and the South Eastern League before it was incorporated. There were to be forty-eight league games in all, plus friendlies arranged throughout their first professional season. A later director of the club was the jeweller Robert Arthur Jones. The first player signed by the new club had previously played for Southend Athletic. The second player signed was Alfred Ernest Watkins, an international player formerly of Millwall Football Club. The goalkeeper was Charles Cotton, late of West Ham. Robert Jack, formerly the manager of Plymouth Argyle, was signed to manage the club. It would appear he returned to Plymouth Argyle for he is shown on the 1911 census return as being a manager of that club when staying with Oliver Trigg, who was then at the Ivy House, Marine Parade. Southend United later played at the Kursaal football ground, then at the Southend Stadium, before returning to Roots Hall to a stadium that was purpose built.

V

Victoria Avenue

Victoria Avenue is the road link between Southend High Street and Prittlewell, interrupted only by the Victoria Circus junction which replaced a roundabout in 2011. It traverses land that was once a brickfields and is now very much an administrative area, although less so than in the past. On the east side of the north end of the road is the Southend Central Museum, which was completed in 1906 as a library. The library later moved next door (replacing a bowling green) and then to another purpose-built

A 'seagull' view of the Victoria Road junction.

Above: The civic coat of arms on a base of the flagpole in Victoria Avenue.

Left: The Civic Centre tower building in Victoria Avenue.

building behind the west side of the High Street. Further down Victoria Avenue is the police station, law courts and the Civic Centre tower building. On the opposite side of the road was C E Heath House, the home of the Inland Revenue until that organisation moved to Tylers Avenue. Also there, but a little further north where the subway is, was Victoria House (now a converted building), the home of the Department of Health and Social Security, later the Department of Social Security. There was also more than one retailing bank on that side of the road. Moving south was Portcullis House and next door Alexander House, both then home to Customs and Excise. Portcullis House is now demolished and is a car park. When the Inland Revenue merged with Customs and Excise to form HMRC the Inland Revenue moved out of Tylers Avenue and the newly merged organisation occupied Alexander House. Also at the south end of Victoria Avenue is Southend Victoria railway station.

W

War Memorial

The near 40-foot-high Southend war memorial, with its accompanying garden, sits on the cliff at Clifftown Parade and overlooks the Thames Estuary on its south side. It comprises an obelisk made of Portland stone surmounting a stepped platform constructed of the same material. Portland stone is also used for the stone slabs embedded in the ground on its north side, which spells the words 'LEST WE FORGET'. On the east side of the obelisk is a stone flag of the White Ensign; on the west side is a stone flag of the Union Jack. Stone wreaths are on the north and south sides.

The Southend-on-Sea war memorial designed by Sir Edwin Landseer Lutyens.

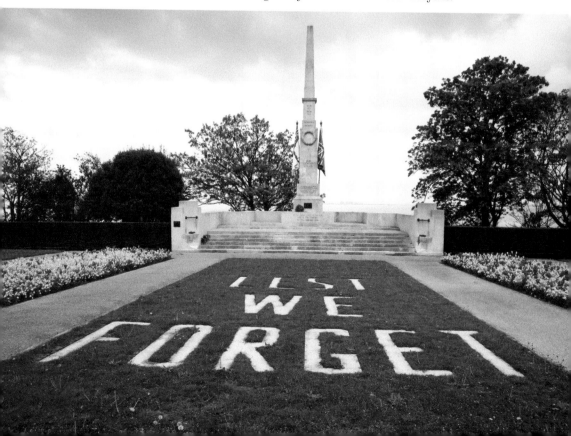

The monument was designed by the renowned architect Sir Edwin Lansdeer Lutyens (1869–1944), who also designed the Cenotaph at Whitehall, London.

The unveiling ceremony took place on Sunday 29 November 1921 with Lord Lambourne, the Lord Lieutenant of Essex, doing the honours. The dedication was done by the Bishop of Chelmsford.

No names are recorded on the memorial. However, the name of each of the 1338 men to whom the memorial is dedicated is recorded on a stone tablet housed in the refectory at Prittlewell Priory.

The 'soldier' who stands guard on the north-west side of the memorial is a recent addition.

A 'soldier' stands guard at the war memorial.

Xmas at Southend

Christmas celebrations at Southend appear to have come to the fore in the 1880s and 1890s. In the High Street there was Cumine's Christmas Fare (Railway Bazaar), or you could visit Payne's Stores in Queens Road if you wanted to join a Christmas club. Six pence would be added to every five shillings paid in. Alternatively, there was the prominently positioned Royal Library run by the Colchester-born Zillah Bullock. She offered cards, toys, books, games and ornaments for the Christmas tree. Dressing dolls was a speciality.

Mrs Bullock purchased the Royal Library business in around 1881 at a cost of £850 for stock and £200 for good will, although the £850 was not immediately due – she

Christmas: a time for festive cheer and ghost stories.

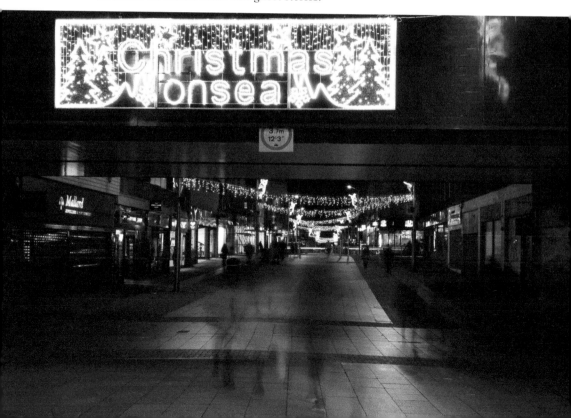

Christmas lights at the Royals shopping centre.

had five years to pay. Zillah traded there for around twenty years, so saw out many Christmases, but unfortunately went bankrupt. Apparently, her husband, Charles Bullock, would regularly take monies from the till, £20 or £30 at a time, and then disappear for a few days without telling his wife where he was going. He lost money by keeping greyhounds and staying in hotels at Southminster. One of his dogs won the South Essex Cup but was disqualified for being wrongly registered. He physically assaulted his wife, too, which resulted in separation. It was too late to save the business; the financial damage had already been done. Zillah borrowed money from friends to keep the business afloat. She also borrowed from money lenders at high interest rates. Zillah's last Christmas trading was in 1900. She had £3,229 of debt with only £1,073 of assets. Zillah later became a manageress of a private hotel.

A year earlier, in 1889, Christmas fell on a warm sunny day. Topcoats were not required and considered something of a hindrance. On Christmas Eve the Volunteer Artillery Band played throughout the night into the early hours of Christmas morning. The Peculiar People, of which there were around thirty, sang carols from 5 a.m. The Salvation Army joined the festive celebrations later in the day, no doubt at a more respectable hour.

At Christmas 1905, 1,315 children of the unemployed sat down to dinner at the Albert Hall in the Ship Hotel, on Marine Parade. It was an idea put forward by George Myall junior, the son of Southend's first coxswain. They ate roast beef, boiled mutton and stewed rabbit, all with vegetables, of course, followed by mince pies. Nuts, sweets and apples were later distributed and the children were entertained by a Punch and Judy show. Also present was the Prittlewell Brass Band. The champion collector towards the cost of the event was Miss Harcourt of the Hope Hotel, who collected £8, some achievement; her nearest rival collected £3 less.

Y

Yantlet Line

The Yantlet Line was an imaginary line drawn from the south bank of the River Thames at Yantlet Creek on the Kent coast to the north bank of the River Thames at Chalkwell on the Essex coast. At each end of the line there was erected a London Stone. The line between the stones marked the boundary of the eastern end of the jurisdiction of the City of London over the River Thames from as long ago as the late twelfth century when the rights were purchased from Richard I.

The stone at Chalkwell is known as the Crowstone (or Crow Stone), and this was erected in 1837, according to a plaque on its north side. Some newspaper reports give

The west-facing side of the Crowstone at Chalkwell seen at high tide.

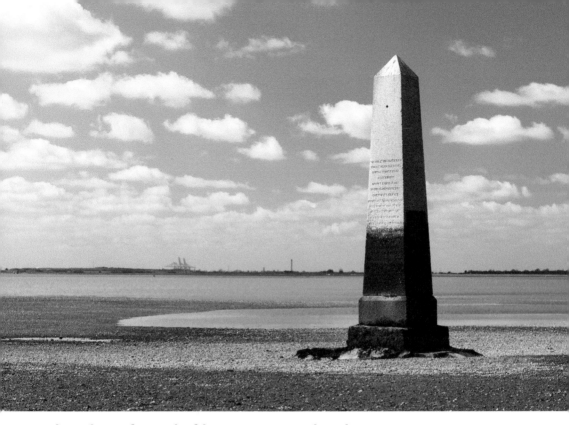

Above: The east-facing side of the Crowstone seen at low tide.

Below: Since 1950 the old Crowstone has stood at Priory Park, Prittlewell.

the date of its installation as 1838. To confuse matters further, the west side of the obelisk carries the words 'God preserve the City of London 1836'.

This granite obelisk, however, was placed next to an older stone which was erected on 25 August 1755 by the then Mayor of London, Sir Stephen Theodore Janssen, a master of the Stationer's Company. The old stone stood for nearly 200 years until its removal to Priory Park in 1950, where it stands today, just outside the west wall of the priory itself. This stone, half the height of the present one, carries the City of London coat of arms at the top of what was its west-facing side but now its south-facing side as it stands in the park. It also carried the date 1285, which has been eroded. This is the date when Edward I first controlled the City of London and he appointed Sir Ralph Sandwich (1235–1308) the warden, effectively making him the Lord Mayor of the City (1285–93).

Usually the Lord Mayor of London (but not exclusively so) would officiate a ceremony at the stone every six or seven years to reinforce the City of London's claim to the jurisdiction of the river west of the Yantlet Line. The last name to appear on the old stone was that of William Taylor Copeland who visited in July 1836. The first name on the new stone is that of Sir John Pirie. His visit took place in July 1842.

These ceremonies were quite an event. On 23 July 1816 (Sir) Matthew Wood, the Lord Mayor of London, a fishmonger and friend of (Sir) William Heygate, arrived at Southend on board the yacht *Trinity* late in the afternoon. After a cold dinner on *Trinity*, Matthew and his party boarded the water bailiffs' eight-oared sallop, which took them as close to the shore as it could go due to the low tide at the time. Matthew boarded William's carriage but the horse got stuck in the mud and in trying to free itself was nearly strangled by the collar, which caused the Lord Mayor to jump into the water. During the evening the Lord Mayor gave a ball at the Royal Hotel, but, due to his earlier mishap, he was late arriving. Supper was enjoyed, and a Mrs Hengler of Vauxhall directed a fireworks display at the Terrace before dancing commenced. The dancing did not cease until 5 a.m., which was quite usual for such events held at the hotel. On the following morning the Lord Mayor was taken to the Crowstone by carriage where a mason had been waiting to cut into the stone the Lord Mayor's name with the date and year of the event. On completion the Lord Mayor placed the state sword on the stone to claim that part of the river under the city's jurisdiction. The City of London colours were flown next to the stone. Due to the high spring tide the 1816 ceremony took place in boats. On arriving back on shore the Lord Mayor distributed wine and new pieces of silver to the onlooking crowd. The Lord Mayor then returned to Southend before departing for the Crown Inn at Rochester where he stayed overnight. In the morning he visited the London Stone at the mouth of Yantlet Creek.

The name of (Sir) William Heygate, incidentally, was inscribed on both stones.

Zeppelin Attacks

In January 1915, nearly six months after the start of the First World War, German Emperor Wilhelm II authorised Zeppelin airship attacks on England. The first batch of incendiary devices was dropped in Norfolk at Great Yarmouth and King's Lynn, resulting in a total of four persons being killed. Attacks on Essex followed with Southend being the target during the early hours of 10 May 1915, which is where the next fatality occurred. The unfortunate person was Agnes Frances Whitwell, who was in bed with her husband at No. 120 North Road, Westcliff, when the bomb struck. Agnes, who was born at Tollesbury in Essex, died at the age of sixty and is buried at Sutton Road Cemetery. Her husband, George, was badly burned but lived on until 1923.

The Zeppelin bombing run is said to have begun at York Road with the first bomb released at around 2.45 am. Southchurch Road was also hit with the builders' yard of James Catchpool Flaxman at No. 70 completely destroyed. The Great Eastern Railway goods yard was targeted and several bombs were dropped in the vicinity of the pier and Queen Mary Hospital. The Zeppelin airship then moved westwards towards Leigh-on-Sea where, fortunately, there were no casualties. In all some sixty bombs (estimates vary) were dropped on the borough and places hit included London Road, Baxter Avenue, Hamlet Court Road and Cromwell Avenue, causing an estimated £10,000 worth of damage. At London Road the Cromwell Boarding House was gutted. Sidney Herbert Perren, a Westcliff resident at No. 27 Ceylon Road and the London manager of the *Sheffield Daily Telegraph*, is quoted in the newspaper of the same name: 'I was awoken at 3am by two heavy explosions. This was followed by the steam hooter, which is arranged to give the alarm at any time aircraft make their appearance over Southend.' He went on to say one bomb landed around 12 yards from where he was standing and another hit a butcher's shop backing onto his garden.

Two weeks later there was another attack on the town resulting in three casualties. Thirty-five-year-old May Fairs was staying with her mother at a bungalow off Southbourne grove, Westcliff, which was owned by May's Father, William, a chemist and dental surgeon of Old Ford Road in Bow, London. May and her mother had gone to the railway station to meet him. Shortly after stepping off the tramcar at Eastwood

A stereo image of the Cromwell Board residential home gutted by a Zeppelin attack. (Courtesy of the Library of Congress)

Lane, Westcliff, May received a blow to the head, instantly killing her. At the inquest into her death Major Reginald Paul identified metal fragments found at the scene to be from shells fired by anti-aircraft guns. Thus, it was a fragment from a spent shell fired by our own guns that killed her rather than anything dropped from the German airship. The second victim was seven-year-old Marion Pateman (affectionately known as Queenie), the daughter of John Pateman, a boot repairer at Broadway Market, near where Victoria Circus is today. Young Queenie was asleep in bed when the bomb struck. She was rescued from the flaming bedclothes by her mother and older sister, Minnie, who bravely picked her up and extinguished the flames. Unfortunately, Queenie later died in hospital. Florence Smith, the daughter of Horace Mills of Newark and the wife of Frank William Smith, who was an architect assisting the surveyor of the Borough of Southend, became the third victim. Frank and Florence lived at Westminster Drive, Westcliff. Florence was taken to hospital where she survived for over two weeks. After her death her body was transported to Newark cemetery, Nottinghamshire, which is where her funeral was held.

Both Zeppelin attacks appear to have been carried out by only one airship, although some of the timings given to newspaper reporters by onlookers suggest it may have been two.

Further Reading

Many books have now been written about Southend and in the main part each book complements the others. For a good overview of the Borough of Southend there is Ian Yearsley's *A History of Southend* (Phillimore). He has also written *Southend in 50 Buildings* (Amberley). Judith Williams has written *A History of Leigh on Sea* (Phillimore) and *Shoeburyness: A History* (Phillimore), a good introduction to both places. To compare old photographs with new there is Ken Crowe's *Southend Then and Now* (History Press) and this author's *Southend Through Time* (Amberley). Carol Edwards has self-published several books on specific places within the Borough of Southend and Martin Easdown has put together an interesting selection of old photographs of *Southend Pier* (Tempus Publishing Ltd). Other books about Southend are available and no doubt more will be published in the future

Acknowledgements

Many sources were used in researching this book, which space will not allow me to mention here. However, it is perhaps worth mentioning that I have accessed the British Newspaper Archive website, looking at local newspapers, but not exclusively so. The Ancestry website has also been accessed when a query has arisen.

All the photographs in this book were taken by the author except those few images sourced from the Library of Congress (LOC), United States of America. Where an LOC image has been used this is noted in the caption.

I would like to thank the lady at St Mary Prittlewell for allowing me to take photographs inside the church. Last, but not least, my thanks to Nick Grant for asking me to write this book and to Jenny Stephens and her team at Amberley.